Art in Context

Edited by John Fleming and Hugh Honour

Each volume in this series discusses a famous painting or sculpture as both image and idea in its context – whether stylistic, technical, literary, psychological, religious, social or political. In what circumstances was it conceived and created? What did the artist hope to achieve? What means did he employ, subconscious or conscious? Did he succeed? Or how far did he succeed? His preparatory drawings and sketches often allow us some insight into the creative process and other artists' renderings of the same or similar themes help us to understand his problems and ambitions. Technique and his handling of the medium are fascinating to watch close-up. And the work's impact on contemporaries and its later influence on other artists can illuminate its meaning for us today.

By focusing on these outstanding paintings and sculptures our understanding of the artist and the world in which he lived is sharpened. But since all great works of art are unique and every one presents individual problems of understanding and appreciation, the authors of these volumes emphasize whichever aspects seem most relevant. And many great masterpieces, too often and too easily accepted and dismissed because they have become familiar, are shown to contain further and deeper layers of meaning for us.

Art in Context

Claude-Oscar Monet was born in Paris on 14 November 1840, the second son of a grocer, and died at Giverny (Seine) on 6 December 1926. He was brought up in Le Havre, where he met Boudin, who persuaded him to take up landscape painting. From 1860–62 he did military service in Algeria but, falling ill, was bought out by his parents. He then studied at the Académie Gleyre in Paris, where he met Bazille, Sisley, and Renoir. By 1865, when the Déjeuner sur l'herbe *was begun, he was already accepted by these young friends as a leader. During the middle years of the decade he came to know Pissarro, Courbet, Cézanne and Manet. In 1874 he exhibited a painting called* Impression, Sunrise *at the first exhibition of the Société Anonyme des Artistes-Peintres, and this title was used derisively to name the whole group* Impressionists. *He gradually became known during the 1880s, and for the last thirty years of his life was generally regarded as the greatest Impressionist painter.*

Le Déjeuner sur l'herbe was painted in oil on canvas (approximately fifteen feet high by twenty feet wide). After many preparatory drawings and sketches made at Chailly in the forest of Fontainebleau during the summer of 1865, it was begun in Paris in the fall and abandoned unfinished in about April 1866. Only two fragments now survive, in the Louvre, Paris, and in the Eknayan collection, Paris.

Allen Lane The Penguin Press

Monet: Le Déjeuner sur l'herbe

b 1890 ⟶ d 1926

Joel Isaacson

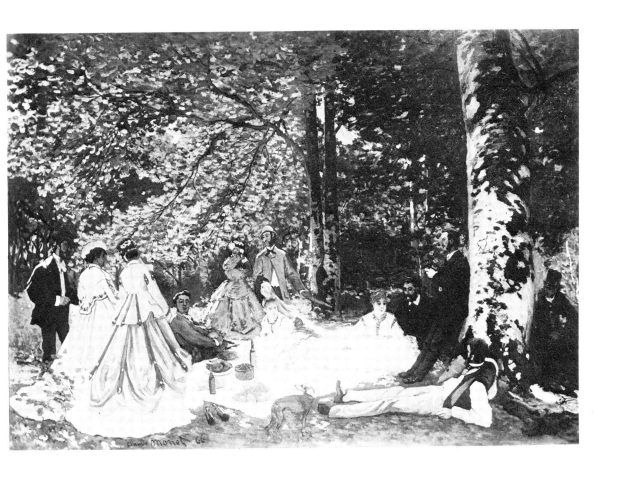

Copyright © Joel Isaacson, 1972
First published in 1972
Allen Lane The Penguin Press, 74 Grosvenor Street, London W1
ISBN 0 7139 0228 0
Filmset in Monophoto Ehrhardt by Oliver Burridge Filmsetting Ltd, Crawley, England
Colour plate printed photogravure by D. H. Greaves Ltd, Scarborough, England
Printed and bound by Jarrolds, Norwich, England

Designed by Gerald Cinamon

To Helen, Elisa and David

Reference color plate at end of book

Preface

This study was greatly facilitated by a Faculty Research Grant from the Horace H. Rackham School of Graduate Studies of the University of Michigan in spring 1968 and by earlier fellowships received from the Woodrow Wilson Foundation and the Haskins Memorial Alumni Fund of Oberlin College. It derives in part from my doctoral dissertation, 'The Early Paintings of Claude Monet', University of California, Berkeley, 1967.

I would like to thank Mr Daniel Wildenstein, Mr Rodolphe Walter and the staff of the Cabinet des Estampes, Bibliothèque Nationale, Paris, for their responses to my inquiries, and Mr Marvin Eisenberg and Mr Benedict Nicolson for their interest and encouragement in reading earlier versions of the essay. Mr Theodore Shabad and Mr Robert Beetem kindly took photographs for me during phases of preparation, and Mr Richard S. Davis and Mr Paul Mellon generously provided me with photographs of works in their collections. I also must thank the Laboratoire de Recherches des Musées de France for permission to reproduce an X-ray photograph of a detail from the Louvre version of the *Déjeuner sur l'herbe*, the Bibliothèque d'art et d'archéologie, Paris, for permission to publish the two Monet letters in the appendix, and Mr Mark Roskill for supplying me with the manuscript of his essay on Monet's use of fashion illustrations. I would like, as well, to express my gratitude to Mr John Fleming for his diligent reading of the manuscript and for many helpful suggestions.

A brief survey of the literature on the *Déjeuner sur l'herbe* may be found in note 6 on pages 96–8.

Ann Arbor, 1970

Historical Table

1860 Garibaldi takes Sicily and Naples. Lincoln elected U.S. president

1861 Kingdom of Italy proclaimed. French expedition to Mexico. American Civil War begins.

1862 Bismark appointed Prussian premier. Treaty of Saigon between France and Annam. France annexes Cochin-China.

1863 French protectorate established over Cambodia. Confederates defeated at Gettysburg. Lincoln declares slaves to be free.

1864 Austria and Prussia declare war on Denmark. Pius IX issues Syllabus of Errors condemning Liberalism, Socialism, Rationalism. Formation of First International.

1865 Lincoln assassinated. American Civil War ends. U.S. demands recall of French troops from Mexico.

1866 Prussia defeats Austria at Sadowa; concludes secret military alliances against France.

1867 North German Confederation formed by Prussia. French troops quit Mexico. Death of Emperor Maximilian.

1868 Bakunin founds International Social-Democratic Alliance.

1869 Suez Canal opened by Empress Eugénie of France.

1870 Franco-Prussian War. Napoleon III capitulates at Sedan.

Monet called up for military service, sent to Algeria.
 Degas's *Young Spartans Exercising.*
Delacroix finishes Saint-Sulpice murals. Manet makes
 Salon debut, receives honorable mention. Garnier
 begins Paris Opera House.
Monet becomes ill, bought out of army by family;
 enters Gleyre's studio, meets Bazille, Sisley, Renoir.
 Manet's *La Musique aux Tuileries.*
Death of Delacroix. Salon des Refusés. Manet's *Le
 Déjeuner sur l'herbe,* Whistler's *The White Girl.*

Monet's first serious season of painting, on Normandy
 coast. Corot's *Souvenir de Mortefontaine*
 Rodin's *Man with a Broken Nose.*

Salon: Manet's *Olympia;* Monet makes debut with
 two seascapes.
 Monet: *Le Déjeuner sur l'herbe*
Degas's *Steeplechase,* at Salon. Manet's *Le Fifre* refused
 at Salon. Monet's *Femmes au jardin.*
Death of Ingres. Manet and Courbet hold one-man
 shows across from Paris World's Fair. Manet's
 Execution of Emperor Maximilian. Monet's *Terrace
 at the Seaside;* he and Renoir paint views of Paris.
Monet's *The River* and Renoir's *Sisley and his Wife.*

Renoir and Monet paint at La Grenouillère.
 Carpeaux's *La Danse* (Paris, Opera).
Fantin-Latour: *A Studio in the Batignolles Quarter.*
 Bazille killed in action. Monet goes to England.

J. Burckhardt, *The Civilization of the Renaissance
 in Italy.* — 1860
Baudelaire, *Fleurs du mal,* second edition. *Tannhäuser
 produced in Paris.* — 1861
Flaubert, *Salammbó.* Hugo, *Les Misérables.* Helmholtz,
 Sensations of Tones — 1862
Baudelaire, *Le Peintre de la vie moderne.* Renan, *Vie de
 Jésus.* Viollet-le-Duc, *Entretiens,* vol 1. — 1863
E. and J. de Goncourt, *Renée Mauperin.* Fustel de
 Coulanges, *La Cité antique.* — 1864
E. and J. de Goncourt, *Germinie Lacerteux.* Taine, *La
 Philosophie de l'art.* P.-J. Proudhon, *Du Principe de
 l'art et de sa destination sociale.* — 1865
Hugo, *Les Travailleurs de la mer.* Verlaine, *Poèmes
 saturniens.* Zola, *Mon Salon.* — 1866
Baudelaire dies. Zola, *Thérèse Raquin.* Marx, *Das
 Kapital,* vol. I. — 1867

1868

Flaubert, *L'Éducation sentimentale,* Lautréamont, *Les
 Chants de Maldoror.* Wagner, *Rheingold* — 1869

1870

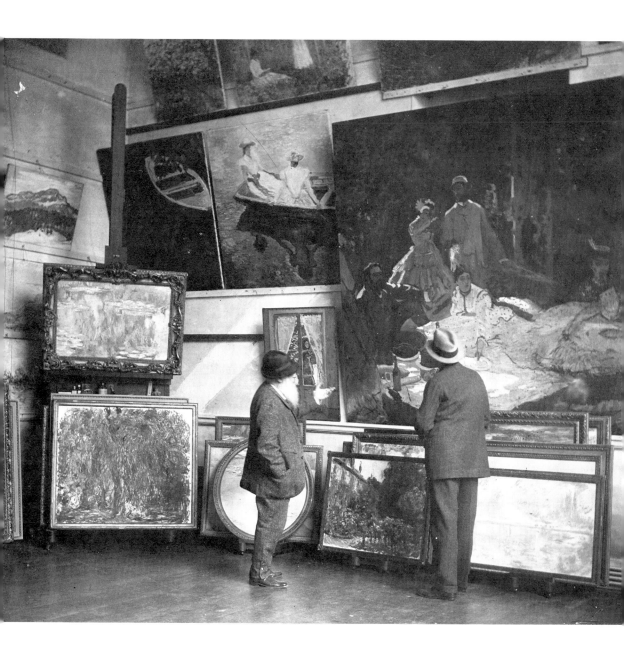

1. Introduction

In the spring of 1865, Claude Monet began to implement a project which must have been forming in the back of his mind since the appearance of Manet's *Déjeuner sur l'herbe* at the Salon des Refusés of 1863. Up to 1865 Monet had devoted himself primarily to land-scapes, seascapes, and an occasional still life or portrait, works which stemmed for the most part from his early, informal training under Eugène Boudin and Johann-Barthold Jongkind. Two of his marines had just been accepted at the Salon, where they were to earn a striking though limited critical success, but even before the Salon opened on the first of May, Monet left Paris for the town of Chailly on the edge of the Fontainebleau forest, where he set to work to put his plan into effect. There the twenty-four-year-old artist deter-mined to realize what Emile Zola was to describe two years later as 'the dream of every painter: to put life-size figures in a landscape'.[1] Zola felt that Manet had achieved this ideal in 1863, when he painted the *Déjeuner sur l'herbe*. But Monet's project was to approach the dream more closely. He envisioned the contemporary theme of a picnic which, portrayed in a neutral and objective fashion, would avoid the artificialities and the problematic historicism of Manet's *Déjeuner*. The subject of his painting was to derive from the simplest of common experiences and the style was to evolve from the faithful, on-the-spot observation of figures circulating in the open air. In form and content Monet's project, his own *Déjeuner sur l'herbe*, was conceived as a grand summation of the realist tradition in painting and as a manifesto of the new concerns for contem-poraneity and fidelity to nature which were emerging as the major objectives of the modern artist.

Monet intended to submit his painting to the 1866 Salon. But he failed to finish it in time and was ultimately forced to abandon the extremely large, fifteen-by-twenty-foot, canvas upon which he

1. Monet in his Giverny studio, 1920

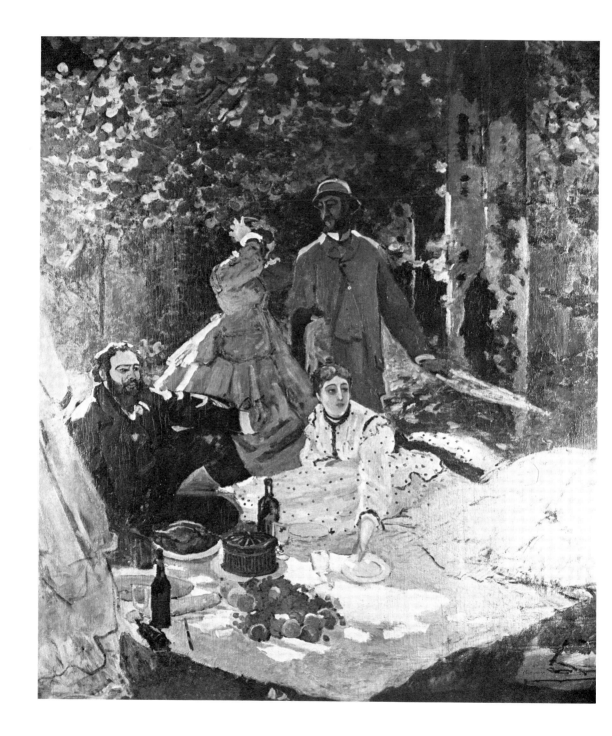

2 (*left*). *Le Déjeuner sur l'herbe*, Claude Monet, central fragment, 1865–6

3. Sketch for *Le Déjeuner sur l'herbe*, Claude Monet, 1865–6

sought to give form to his idea. He still had it in his possession more than ten years later when, in January 1878, he left it with his landlord in Argenteuil in lieu of payment of rent. He did not retrieve it until 1884, at which time he found it partly ruined by damp.[2] It must have been then that he cut away the right-hand portion, which had suffered the worst damage, dividing the remainder into two parts. He eventually stretched the central section and hung it in a prominent position in his studio at Giverny, where it was seen by visitors during his later years [1, 2]. Monet occasionally discussed it with interviewers, referring to it as his *Déjeuner sur l'herbe*.[3] After his death in 1926 it passed into private hands and has remained in relative obscurity to the present day. As a result the

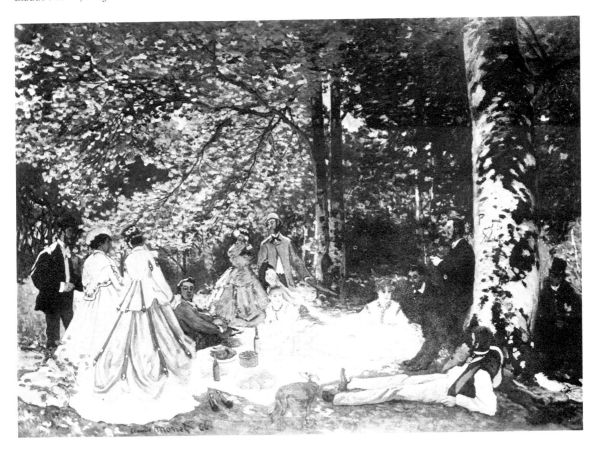

project has been known primarily through a four-by-six-foot oil of the entire composition, which served as the final sketch for the definitive canvas [3 and color plate]. This sketch has been frequently recorded and reproduced but has, in fact, rarely been seen by the Western public, having left Monet's hands to enter the Stchoukine collection in Moscow early in the twentieth century, whence it was absorbed into the Pushkin Museum.

The central fragment [2] was thought to have been all that remained of the actual final painting until, early in the 1950s, Georges Wildenstein discovered, rolled up in a corner of Monet's Giverny studio, the left-hand section of the canvas. Thus whereas Manet's *Déjeuner sur l'herbe* achieved an immediate and lasting notoriety, Monet's painting had no public history in the nineteenth century, and indeed the existence of the huge, fragmented, definitive version of his *Déjeuner* was all but unknown until Mr Wildenstein donated the newly found left-hand portion to the Louvre in 1957, bringing the work to general attention for the first time [4, 5].

Thus the major painting of Monet's young career, a work which might have been 'the picture of the century',[4] has lain fallow in the history of nineteenth-century French art. Its recent reappearance helps to illumine the period just preceding the emergence of Impressionism. It underscores the difficult, transitional character of that moment, when artists were seeking to find their way out of the past, to establish 'a new manner of painting',[5] while striving to capture on their canvases the character and appearances of the

modern world. Monet's *Déjeuner*, however, like the work of Manet which has placed its indelible stamp upon our understanding of the decade of the 1860s, looked both forward and back. It attempted to sum up in a monumental fashion the great Renaissance tradition of pictorial illusionism from which it sprang at the same time that it sought to project possibilities for a new style of painting and a new conception of the canvas as a field for abstract invention. These conflicting goals were not easily reconciled, and Monet's inability to do so should be recognized as the primary reason for his failure to bring the work to completion. The discussion which follows attempts to reconstruct the history and understand the meaning of this magnificent failure.[6]

4 (*left*). *Le Déjeuner sur l'herbe*, Claude Monet, left-hand section, 1865–6

5. Diagram of surviving fragments of *Le Déjeuner sur l'herbe*

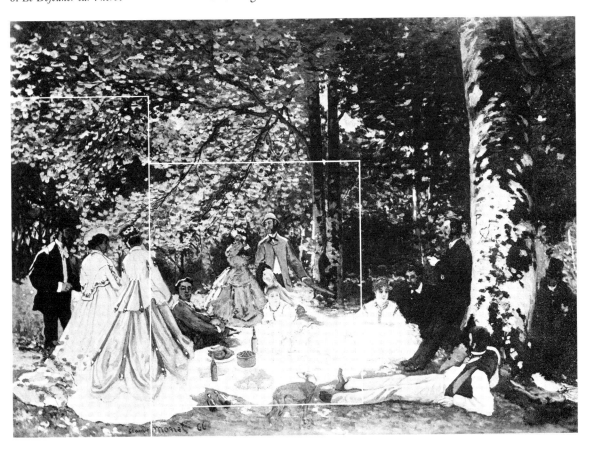

2. Genesis and Development of the Project

During the summer and fall of 1864, Monet enjoyed his most active and productive period of painting to date. Working in familiar surroundings on the Normandy coast, where he had grown up, he produced a succession of seascapes – the port of Honfleur, the beaches at Honfleur and Sainte-Adresse, just above Le Havre – interspersed with views of the town of Honfleur and its environs, attempts at still life and portraiture, and two panels done on commission for his first patron. During the summer, he worked with Boudin and Jongkind and in the course of approximately a six-month period his hand improved considerably. He was able to return to Paris in the late fall with canvases of sufficient quality to earn his initial entry to the Salon and the generous approval of several critics, such as Gonzague Privat, who did not hesitate to call Monet's two seascapes 'the best in the exhibition',[7] and the pseudonymous Pigalle, who termed the *Embouchure de la Seine* 'the most original and supple, the most solidly and harmoniously painted marine that has been exhibited in a long time'.[8] The fresh yet carefully controlled character of the *Embouchure* and his other entry, *La Pointe de la Hève à marée basse* [6], is well conveyed in the approving description by Paul Mantz in the *Gazette des Beaux-Arts*: 'the taste for harmonious color combinations through the play of analogous tones, the feeling for values, the striking effect of the whole, a hardy way of seeing things and forcing himself upon the attention of the spectator, these are qualities which M. Monet already possesses to a high degree.'[9] Monet, up to this point, was very much the pupil of Boudin and Jongkind. Though he surpassed them in breadth and economy of description and in the rather large size of his paintings, he employed, as did Boudin, subdued gray harmonies to which all his colors were made to adhere, and he

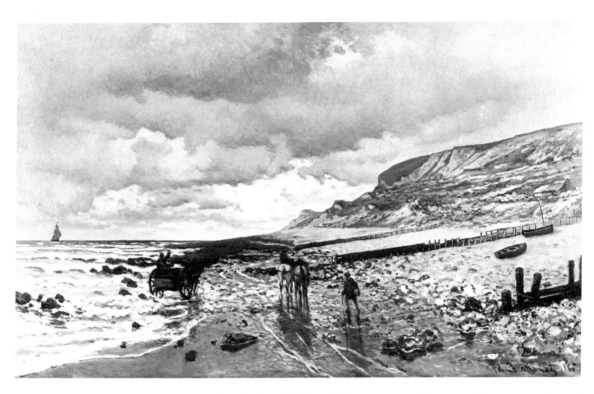

6. *La Pointe de la Hève à marée basse,*
Claude Monet, 1864

shared Jongkind's subjects, sense of compositional control, and shorthand, sketchy manner of depicting landscape forms. By the beginning of 1865 he showed promise of becoming a distinguished member of the independent school of landscape painting which had grown up along the Channel coast in the area of the Seine estuary during the preceding generation.[10]

Upon Monet's return to Paris from Normandy toward the end of 1864, he and Bazille decided to share a studio. Their burgeoning friendship, begun two years earlier when they were both students in the studio of Charles Gleyre, had been consolidated the previous spring. At that time Bazille joined Monet briefly in Normandy, where they painted together some of the coastal motifs which Monet was to concentrate upon throughout the summer and fall. On 5 January 1865 they took an atelier at 6 rue Furstenberg, in the same building in which Delacroix had worked until his death in August

1863. There Monet prepared the paintings which marked his debut at the Salon. It was at that juncture that he decided to put aside his earlier pursuits and enter upon a major new effort, for which his previous experience had only partially prepared him.

In late March or early April, after having submitted his two canvases to the jury, Monet left for Chailly, where he began to put his bold plan for the *Déjeuner sur l'herbe* into effect. On 9 April he wrote to Bazille, describing the fine weather and urging his friend to join him.[11] It is unclear whether Monet even returned to Paris for the opening of the Salon on 1 May, for on 4 May he wrote again from Chailly, asking Bazille to bring paper and pencils and adding in a postscript: 'I would like very much to have you here. I would like your opinion on the choice of landscape for my figures. Sometimes I'm afraid of making a mistake.'[12] Bazille did not accede to his friend's invitation, for he had recently accepted a commission to do two panels for the apartment of an uncle who lived in Paris.[13] Monet's letter referred to this, noting that Bazille could find plenty of time to work on them in the inn at Chailly when the weather was too poor for painting outdoors. In addition to describing thus, by inference, his own general procedure, Monet's letter indicates that he was concerned at that stage with sketches and preliminary studies of figures and landscape.

Several of these studies, whether from this or a slightly later phase, have survived. At least three canvases illustrate his initial selection of a landscape setting for the picnic group [7, 8, 19],[14] all depicting the Bas-Bréau road, about a mile and a half from Chailly. Two are of considerable dimensions for a landscape, over four feet wide, revealing thus their semi-independent relationship to the *Déjeuner* project [7, 8]. It seems clear that they were also intended as works complete in themselves, one of them [8] being chosen by Monet to represent him at the Salon of 1866, where it was accepted.[15] It is not certain at what point or points in his work Monet painted these landscapes,[16] but he may have been led to concentrate upon them by the continued absence of Bazille. His figure essays, during

7. *Le Pavé de Chailly*
dans la forêt de Fontainebleau,
Claude Monet, 1865

8. *La Route de Chailly à Fontainebleau,*
Claude Monet, 1865

the spring and more than half the summer, were probably confined, with rare exceptions, to studies of his mistress (and future wife) Camille Doncieux, who apparently had entered Monet's life only shortly before. She posed for all the female figures in the *Déjeuner sur l'herbe* and was to be his principal model until her death in 1879.[17]

Three drawings related to this phase of Monet's activity, prior to Bazille's belated arrival, have survived. A large charcoal sketch of the projected picnic group was discovered by Gabriel Sarraute in 1947 at the estate of the Bazille family in Montpellier [32]. It presents in setting (the Bas-Bréau road is evident) and composition an early stage in the evolution of the scheme. A second, similar drawing, in pencil, also exists in a still unpublished sketchbook included in the Michel Monet bequest to the Musée Marmottan in Paris. The drawing is partly obscured by another, later landscape sketch penciled in lightly over it, but it is clear enough, in the disposition of figures, to indicate a more advanced stage in the working out of the group composition; it assumes an intermediate position between the drawing found in Montpellier and the large painted sketch of the ensemble in Moscow [3].[18] A third drawing, also discovered by Sarraute at the Bazille home, depicts the standing figure of Camille [30]. It is, however, less securely tied to the *Déjeuner*; in pose and dress it relates both to it and to the *Femmes au jardin* of 1866–7 [45], the major painting to which Monet turned after abandoning the *Déjeuner*.[19]

As spring wore on into summer, Bazille's absence was increasingly felt.

'You have promised to help me with my painting', Monet wrote to him, probably between late June and early August. 'You were to come to pose for several figures, and without that I will not be able to do my picture . . . I beg of you, my dear friend, do not leave me in such difficulties. All the studies are going marvelously; only the men are lacking . . . I no longer can think of anything but my painting and if it doesn't work out, I believe I will go crazy. Every-

one knows that I am doing it and encourages me very much. So it must be done, and I count on your past good friendship to bring you here quickly to help me.'[20]

But Bazille did not respond. On 16 August, still in need, Monet was forced to repeat the same refrain: 'I am in despair. I feel that you will be the cause of my picture's failure and that will be very bad for you after having promised to come to pose.'[21] At that point, Bazille completed the paintings for his uncle's apartment and hastened to Chailly.

He arrived in the latter part of August 1865.[22] Five days later he wrote to his parents that, due to bad weather, he had been able to pose only twice thus far, adding that Monet would need him for at least three or four days more.[23] In fact, Bazille's stay was extended beyond this, for Monet was accidentally wounded in the leg and confined to his bed for a number of days. Bazille's *L'Ambulance improvisée* shows Monet in bed with the contraption which Bazille, calling upon his earlier training as a medical student, had devised to ease his friend's pain [9].[24] Bazille had time to do several other

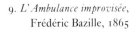

9. *L'Ambulance improvisée*, Frédéric Bazille, 1865

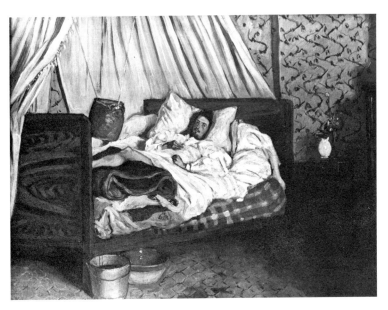

paintings during his stay in Chailly: two forest landscapes, a self-portrait, and a *Repos sur l'herbe*, a minor essay in the genre to which Monet was devoting all his energies [10].[25] The date of Bazille's departure from Chailly is not known, but he was back with his family near Montpellier by 28 September.[26] His visit to Monet may have lasted anywhere from two weeks to just over a month.

10. *Repos sur l'herbe*, Frédéric Bazille, 1865

An oil sketch, *Bazille and Camille – study for 'Le Déjeuner sur l'herbe'* [11], reveals the importance of Bazille's role. It depicts him with Camille as they were to appear at the left side of the Moscow picture [3] and, initially, in the final painting. This sketch is of particular interest as the only remaining example of the painted figure studies from nature which Monet utilized in working up his group ensemble.[27]

Monet must have done most of his work on the painting now in Moscow in September and early October, during Bazille's visit

and just after his departure. By the second week in October he was ready to turn to the final, grand version. To carry out this enterprise, to cope physically with a canvas roughly fifteen feet high by twenty feet wide, he had to have a studio. So he returned to Paris to make use of the atelier which he had rented with Bazille nine months earlier but which he had rarely occupied. On 14 October he wrote

11. *Bazille and Camille – study for 'Le Déjeuner sur l'herbe'*, Claude Monet, 1865

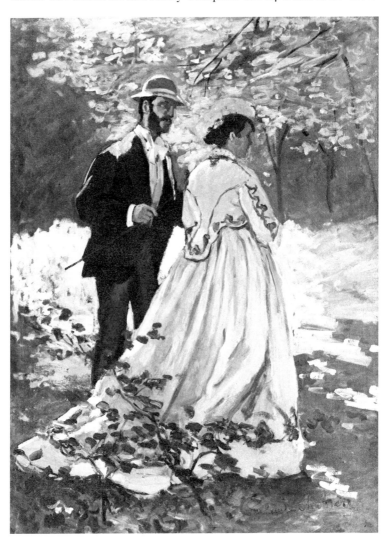

from Paris to Bazille, asking him to send his share of the rent: 'Send me immediately the 125 francs for the quarter; I have some money but only enough for myself, for I have had a great deal of difficulty in getting away from Chailly . . . I am going to get to work on my canvas, everything is ready.'[28] After six months of preparation Monet was about to begin the definitive canvas.

He must have spent the entire fall working in the rue Furstenberg studio.[29] We know that he was actively engaged on the *Déjeuner* in December. Boudin, who had returned to Paris from Normandy in the late fall, wrote to his brother Louis on 20 December: 'I have seen Courbet and others who dare to do large canvases, the lucky ones. Young Monet has one twenty feet wide to cover.' And, at about the same time, he reported to his friend Martin: 'Monet is finishing his enormous sandwich which is costing him the eyes in his head.'[30] Upon Bazille's return from the south, he again shared the rue Furstenberg studio with Monet and in December or January wrote to his parents that they worked side by side every morning.[31] Again, in late January or the very beginning of February, Bazille apprised his parents of his progress on his projected Salon painting and added: 'Monet has been at work for a long time; his painting is well advanced and will have, I am sure, a great effect.'[32] On 4 February, the two friends were evicted from the studio; this time they decided to live separately, Monet moving to 1 rue Pigalle, in the Batignolles quarter. He must have taken his large canvas with him, continuing to work on it in an effort to complete it in time for submission to the Salon jury.[33]

He failed to meet the deadline, however. At the 1866 Salon he was represented by one of his Bas-Bréau landscapes [8] and by a large, full-length portrait of Camille, painted at the last minute in an effort to provide a major entry which might bring a repetition of his success of the previous year [12].[34] He may have then returned to the *Déjeuner* and continued to work on it until some time in April, when he moved to Sèvres, near Ville-d'Avray, just outside Paris. From there he wrote to his friend Amand Gautier, explaining that

12. *Camille*,
Claude Monet, 1866

he had made a major decision, 'that of putting aside *for the moment* all the large things I have under way which are only eating up my money and causing me great difficulties'.[35] Monet must have been speaking primarily of his huge *Déjeuner sur l'herbe*, which he had now abandoned only 'for the moment' due to financial difficulties.

Such were the stages in the evolution of the *Déjeuner sur l'herbe* in so far as it may be re-created from an examination of the fragmentary sources which have come down to us. Monet does not seem to have worked further on the canvas, despite the fact that he had it in his possession in the succeeding years.[36] At an unspecifiable time during 1866 he must have returned to the painting now in Moscow [3]; he probably applied a few finishing touches, perhaps firmed up some passages, in order to secure at least one completed version of his project. Upon accomplishing this task he signed and dated it 1866.[37]

Whereas Monet's letter from Sèvres tells us that financial problems were at least a contributory element in his failure to bring the large canvas to a successful conclusion, other factors must be considered as well. Stylistic and conceptual problems will be discussed below, but one consideration which runs throughout the literature on the painting should be weighed at this point. Gustave Geffroy, Monet's friend and biographer, reports that before the Salon deadline arrived, Courbet suggested some revisions to Monet's canvas which the latter felt bound to accept. Soon after, Geffroy continues, Monet found himself dissatisfied with the modifications he had made and abandoned the canvas in disgust.[38] This jibes with Gaston Poulain's statement that Courbet visited Monet and Bazille at their rue Furstenberg studio early in 1866, complimenting them on their Salon paintings.[39] Geffroy's account is somewhat at variance with the one Monet gave in his interview with the Duc de Trévise in 1920. To Trévise, Monet apparently made no mention of Courbet's intervention, and far from expressing dissatisfaction with the canvas, he confided that he held dearly to this painting, 'so incomplete and so mutilated'.[40]

But although the evidence is both scanty and conflicting one may well believe that Courbet did play some role in Monet's life during the late stages of the *Déjeuner*.[41] Certainly, no other work of this period conforms so faithfully to the spirit and style of Courbet's art as does Monet's Salon canvas *Camille* [12][42] – nor, perhaps, is it altogether without significance that the clean-shaven man seated at the left of the picnic cloth in the Moscow sketch should have become, in the final version of the *Déjeuner*, a stocky, bearded figure closely resembling Courbet [2].[43] Moreover, it was just at this time, early in 1866, that Courbet was making some drastic revisions to a major work of his own, the portrait of *Proudhon and his Family* [13] which had been exhibited at the Salon the previous year.[44]

13. *Proudhon and his Family*, Gustave Courbet, 1865–7

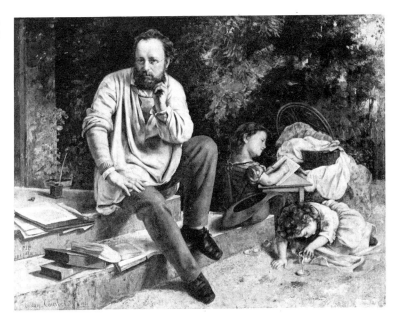

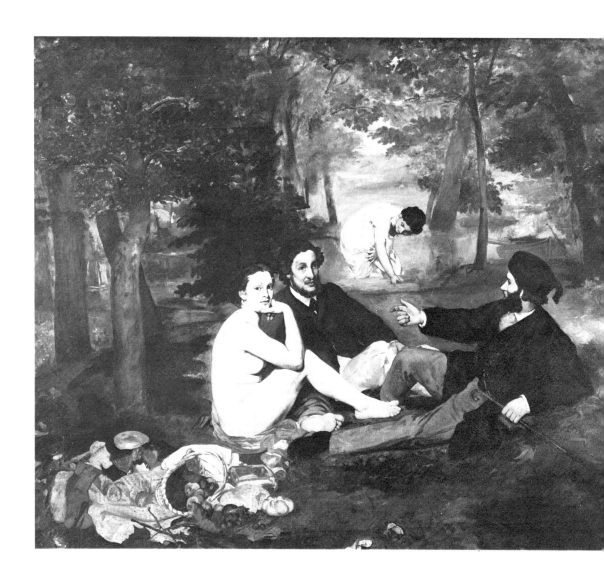

14. *Le Déjeuner sur l'herbe*, Edouard Manet, 1863

3. Theme and Form

In capsule and in relation to the foremost advanced painting of his day, Monet's final painting may be described as a combination of Manet's *Déjeuner sur l'herbe* and *Musique aux Tuileries* [14, 15] blown up to Courbet-like proportions. If one thinks of the two Manet paintings, which were exhibited in 1863, in conjunction with the monumental evocations of Courbet's ego and audacity which are exemplified in the *Burial at Ornans* and *The Painter's*

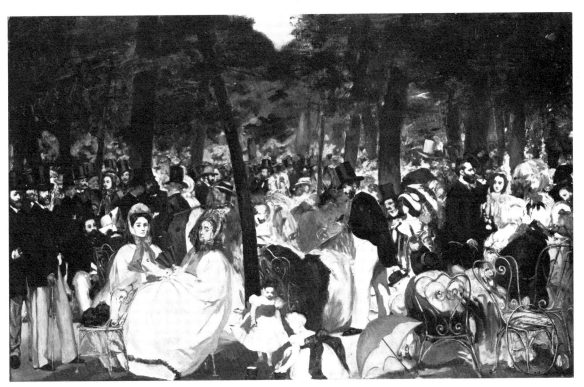

15. *La Musique aux Tuileries,*
Edouard Manet, 1862

Studio, one may approach immediately to a sense of the immensity, the temerity and ambitiousness of Monet's project. Monet conceived his *Déjeuner* in terms of a Salon painting. He was often a fractious and rebellious young man; as an artist he was allied,

despite his training in Gleyre's studio, to a young tradition of independent painting which had grown up outside official circles. His sense of independence was combined, however, with a conventional ambition, that of making his mark within the institutional framework. In 1865 it could hardly have been otherwise. The Salon des Refusés had not been a popular success and its importance was recognized only within an extremely limited and partisan circle. It was not, moreover, a goal to which one might aspire; rather it was something which artists might clamor for only after they had been rejected by the jury. The Salon itself remained the field upon which a young painter had to wage his struggle for recognition, and Monet was sufficiently astute to realize that it was the only possible goal for the grand endeavor he was about to undertake.[45] Indeed, his plan would never have taken the form it did had the Salon not existed. Within these conventional limits, the audacious side of Monet's personality is demonstrated by the grand dimensions which his painting ultimately assumed. A great machine, which the *Déjeuner* was to be, was bound to be noted simply because of its size, and its author would certainly be recognized.[46] If it was not an historical or religious painting but one devoted to a casual scene drawn from everyday life, then it would be even more conspicuous and would bring considerable notoriety as well.

In subject matter Monet's painting takes its place within a long *genre* tradition in Western art, a tradition which, however, in the France of the first half of the nineteenth century, had been over-shadowed by the preference for historical and romantic themes as well as by the growing taste for landscape. Previous to the significant reappearance of contemporary subjects in the art of the 1840s and 1850s, the last important period of genre painting in France occurred during the eighteenth century. It persisted through the early nineteenth century only as a somewhat literary, sentimental, and picturesque mode allied to the larger pursuit of the exotic, the military, the religious, the medieval, the antique as major themes for painting. It lived on, too, in the popular and commercial arts.

Baudelaire, in *Le Peintre de la vie moderne*, described the renewed interest in his day in late eighteenth-century engravers and water colorists, such as Debucourt and Gabriel and Augustin de Saint-Aubin, artists who had devoted themselves to depicting in an easily accessible medium the manners of the elegant world of Paris [16].[47] One may trace a direct line from such drawings and engravings, so often dedicated to the pleasures of the throng disporting itself in the

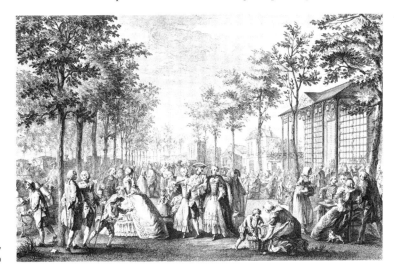

16. *Promenade sur les remparts de Paris*, Augustin de Saint-Aubin, 1760

17. Engraving from *L'Illustration*, 1860

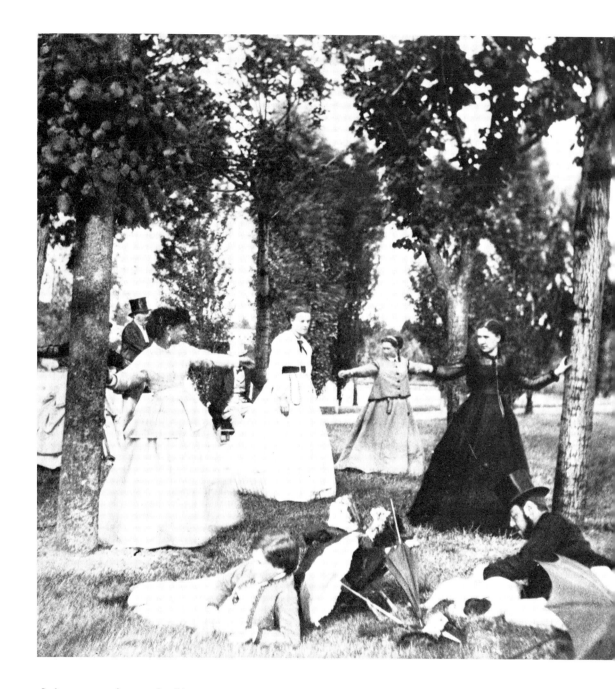

18. Anonymous photograph, 1860s

f Illustration 1860

open air, to the illustrations of contemporary customs and events which abounded in the popular weeklies of the Second Empire [17], and from these to a painting such as Manet's *Musique aux Tuileries* [15]. Monet's *Déjeuner sur l'herbe* also connects with this minor tradition.

It accords, too, in its subject, with a genre which was gaining popularity among the middle classes during the early 1860s. The group photograph of pleasure seekers out of doors – a by-product of the industrial revolution and of the growing need for people to escape for a moment's respite from the new-found cares of urban life – became a standard category of the commercial photographer's enterprise [18]. Among other favorite locales was the forest of Fontainebleau, no longer reserved for the contemplations of the landscape painter. Monet's painting recognizes and records this phenomenon, this pursuit of passing pleasure and spiritual and bodily revivification which was part of his own experience of 'Barbizon'. Aaron Scharf has posed, in addition, the possibility of a formal connection between Monet's Barbizon landscapes and the products of early landscape photography in the same region. He notes similarities of tone and foliage description in both Gustave Le Gray's photographs of Fontainebleau forest, beginning in the 1850s, and the early paintings of the Impressionists. In particular, he remarks the 'striking parallel' between Monet's Bas-Bréau paintings [7, 8 and 19] and Le Gray's photograph of the same subject taken in the early fifties [20].[48] Both painter and photographer utilize the same angled view down the road and achieve an almost identical massing of foliage and overall compositional arrangement. Whether their visual proximity is due to Le Gray's example or the product of a similar vantage point at the side of the road enforced upon or chosen by both men it is difficult to say, but the closeness of these works is indeed noteworthy and underlines the parallelism of the investigative effort made by both the photographer and the painter during the second half of the nineteenth century.

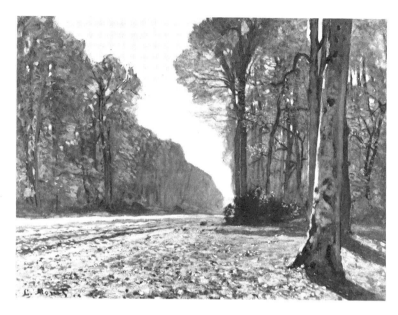

19. *Route du Bas-Bréau*,
Claude Monet, 1865

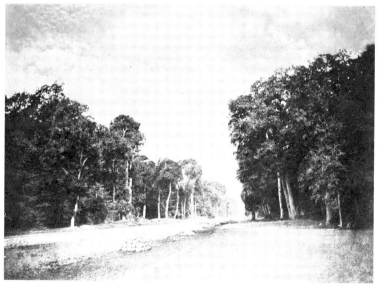

20. Photograph of a road in
Fontainebleau forest
by Gustave Le Gray, 1850s

Monet's concern for contemporary subjects and new visual forms
seems to have been compounded, however, with an interest in the
art of an earlier day. An eighteenth-century hunting picnic, Carle
van Loo's *Une halte de chasse* [21], which was in the Louvre at the

time, may have suggested certain details for the *Déjeuner*. Whereas no direct quotation may be cited, except perhaps for the turn of the dogs' heads, one finds, nevertheless, noteworthy correspondences in the angle of the picnic cloth and the deliberate placement of the objects upon it, in the outstretched legs of the men toward the right front of the cloth in each work, and in the attitudes and gestures of several of the figures. A turn to van Loo's painting would have been consistent with a more general interest in the eighteenth century on the part of Monet and his contemporaries. The great school of French Rococo painting, devoted to the outdoors, to light and color, to atmospheric effects, to the vagaries and delicacies produced by the brush, to the evocation of a form of contemporary life, proved

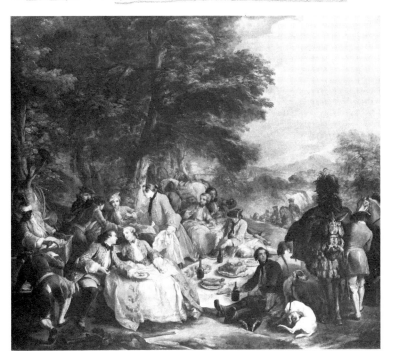

21. *Une halte de chasse,*
Carle van Loo, 1737

attractive to young painters of the Second Empire dedicated to the open air and to a modern iconography. The elegant, pastoral genre of Watteau, Pater, Lancret, and Fragonard stemmed from the last great phase of French art to precede the era of David, whose

contribution had nourished the formal dogmas and rhetorical prescriptions associated with the academic instruction against which Monet and his friends were arrayed. There is an even greater kinship between Monet's *Déjeuner* and that favorite genre of the Rococo masters, the *fête champêtre*, than there is with the engravings extolled by Baudelaire. For Monet's painting is not of the crowd so much as of an intimate, selected group, sheltered by the trees in a secluded pastoral setting. In its combination and arrangement of seated and standing figures, in the number of figures within the group, in the relation of the figures to their

22. *Les Champs-Elysées,*
Antoine Watteau, *c.* 1716–19

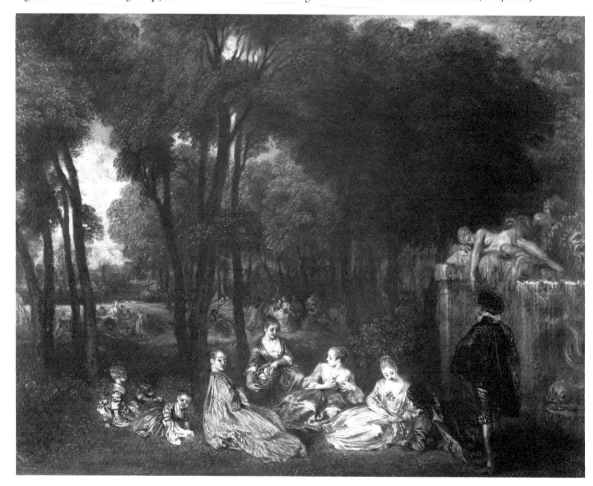

surroundings, in its expression of leisure and the enjoyment of the outdoors, Monet's painting stands as a nineteenth-century middle-class version of the aristocratic idyll of a bygone day [22].[49] In this respect, it relates to the work of Watteau and his contemporaries in much the same fashion as the eighteenth-century paintings compare to works of a related genre from the sixteenth century. Whereas Watteau's elegant idylls modernized and 'secularized', in effect, the mythological scenes – such as bacchanals and feasts of the gods – of Titian, upon which tradition they depend, Monet's *Déjeuner*, true to the social dynamic of its time and accurately reflecting the artist's own class status, expresses the simple pleasures of the hitherto disenfranchised. The right to leisure rather than the privilege of pleasure, the paradisal world of the gods come to roost on earth – such is the larger subject of Monet's *Déjeuner sur l'herbe*.[50]

In seeking to place the stamp of his own age upon his project, Monet was attuned to the most advanced ideas on the role and nature of contemporary art. Hélène Adhémar has suggested that Baudelaire's essay on Constantin Guys, *Le Peintre de la vie moderne*, was a factor in germinating the program of the *Déjeuner* in Monet's mind.[51] But Baudelaire's article was only the most striking presentation of a viewpoint which had been gaining critical and theoretical supporters since the time, twenty years earlier, when Baudelaire himself, in his Salon of 1845, called for a painting which would capture 'the heroism of *modern life*'. Baudelaire saw majesty in the present and urged the painter to seek it out: 'There is no lack of subjects, nor of colours, to make epics. The painter, the true painter . . . will be he who can snatch its epic quality from the life of today and can make us see and understand how great and poetic we are in our cravats and our patent-leather boots.'[52] Increasingly, during the 1850s and 1860s, critics came to emphasize the contemporary as a fit and proper subject for French art, which was seeking to find its own history and nature at the same time that it sought an expression appropriate to a new culture and a new age.[53]

In 1857 the critic Jules-Antoine Castagnary emerged as a staunch advocate of a modern iconography, the advent of which he urged and charted for more than a decade. In his Salon of 1857 he remarked the end of realism as a polemical issue while calling for a realism which would put aside the gods and goddesses in favor of the description of 'man on earth', 'scenes of life . . . the nature which surrounds you'.[54] In 1863, Castagnary noted that French painting was finally learning to be true to itself by depicting 'its own appearances and customs and no longer those of vanished civilizations' and stated that 'the object of painting is to express . . . the society which produces it'.[55]

One seems to find in this year 1863 – the year of the Salon des Refusés, the year in which Baudelaire's essay on Guys appeared – a quickening of the tempo, a greater impatience with convention and a heightened sensing of 'the advent of the *new*'.[56] Théophile Thoré, in reviewing the Refusés, conveyed his sense that 'French art . . . seems to begin or to begin all over again. . . . The subjects are no longer the same as those in the official galleries: very little mythology or history; contemporary life, especially among the common people. . . . Things are as they are, beautiful or ugly, distinguished or ordinary, and in a technique entirely different from those sanctioned by the long domination of Italian art.'[57] In this same year, Pierre-Joseph Proudhon, social philosopher, friend and admirer of Courbet, in formulating his views on the nature and social role of art, lent his pen to the service of the contemporary: 'To paint men in the sincerity of their natures and their habits, in their work, in the accomplishment of their civic and domestic functions, with their present-day appearance, above all without pose; to surprise them, so to speak, in the dishabille of their consciousness . . . such would seem to be the true point of departure for modern art.'[58] Another voice was that of the relatively conservative critic Ernest Chesneau, who, in the course of an essay on realism as the defining current of the French tradition, warned the artist not to leave to the future the task of painting 'our habits, our customs,

our costumes, our feelings and ideas', and asked him to 'perceive and retrace the plastic side of our manners'.[59] By 1866, Castagnary believed that the victory had been all but gained although the battle was not yet over: he observed that landscape, which a decade earlier had been the only representative of the naturalist school, had been 'augmented by the painting of manners', by the 'exact representation of the society which surrounds us and the customs which characterize it'.[60]

That such ideas had entered in generalized fashion into the awareness of Monet and his friends, and that they were still alive in 1866, is indicated by a letter from Bazille to his parents written in late March. In describing his projected Salon painting, Bazille at first contended that the subject mattered little and that his prime concern was that the work be 'interesting from the point of view of painting'. But he continued immediately to affirm his interest in the contemporary: 'I have chosen the modern era because it is the one I understand the best, that I find the most vital for living people, and that is what will get me rejected. If I had painted the Greeks and Romans I would have nothing to worry about, because we still believe in that. They would certainly appreciate the qualities of my painting if I included a peplum or a tepidarium, but I am very much afraid they will refuse my satin dress in a living room.'[61]

Views on the importance of the contemporary were not scarce nor were they new when Monet entered upon his project for the *Déjeuner sur l'herbe*. Nevertheless, Baudelaire's essay on *Le Peintre de la vie moderne* may have been of particular interest to him, for it was linked to the literary and artistic circle which gathered weekly at the home of Bazille's cousin, the commandant Lejosne, whose wife had figured earlier in Manet's *Musique aux Tuileries*.[62] Baudelaire had been a member of Lejosne's cénacle until his departure for Brussels in the spring of 1864. Monet may never have met Baudelaire but he probably heard a good deal about him from Bazille, who had begun to attend Lejosne's cultural soirées shortly after his arrival in Paris at the end of 1862. During the

44

winter of 1864–5, just prior to inaugurating his great project, Monet occasionally joined Bazille at Lejosne's home, thus entering directly into an intellectual atmosphere which had welcomed Baudelaire's ideas. He would not have been receptive to all of Baudelaire's thoughts on modern art, nor is it likely that he followed them closely or would have understood them entirely if he had. Nevertheless, the critic must have earned Monet's confidence several years earlier when he praised Boudin's pastel studies of skies in his Salon of 1859,[63] and the Guys essay probably attracted the artist anew with its ideas on modernity. There Baudelaire advised that a painter who set himself the task of painting a modern subject and then proceeded to seek guidance in the work of the old masters could only be led to a result which would be false, ambiguous, and obscure – undoubtedly congenial words to the young Monet who, despite his apparent recourse to eighteenth-century painting for the *Déjeuner*, was the least sympathetic among the future Impressionists to the art of the museums. Baudelaire's words may have stimulated or fed his desire to provide a challenge to what he later was to term Manet's 'classical' version of the picnic theme.[64]

Baudelaire praised Guys for first observing life and only afterwards setting himself the task of depicting it. He called for a relative rather than an absolute conception of beauty and deemed it the artist's task to isolate the poetry within the contemporary scene, to extract 'the eternal from the transitory'.[65] To accomplish this, to capture the quality and character of the contemporary and thus inject his work into history, the artist, Baudelaire stressed, should observe the traits of his own time as revealed in gait, glance, and gesture. And, in particular, he cited the importance of the artist's coming to grips with the problem of contemporary dress, stating his belief that to substitute the costumes of antiquity for those of the present day was to create an unpardonable anomaly.[66] A striking feature of the final canvas of the *Déjeuner sur l'herbe* is the costume changes which Monet made in the last stages of work. X-ray photographs of the left-hand section show that the costumes of the two

left-hand figures, as they are to be seen in the Washington study and the Moscow sketch, were initially transferred to the Louvre fragment and then painted over (compare illustrations 23 and 24).[67] The changes produced were in the direction of a more up-to-date style, new fashions replacing those of the previous year. Monet's entire project for the *Déjeuner sur l'herbe* is in accordance with Baudelaire's call for modernity. The revisions in costume are consistent with this demand. Baudelaire, for example, praised Guys for his responsiveness to the slightest shift in fashions,[68] and it may well be that the poet's exhortations on the importance of contemporary dress, repeated at several points in his essay, provided the initial motivation behind the changes which Monet effected.

The visual evidence of Monet's project, both in its preliminary and final stages, suggests a still further involvement with contemporary costume, specifically with the illustrations through which fashions were presented to the public. And once again the role of Baudelaire should be considered. In the opening paragraphs of *Le Peintre de la vie moderne*, Baudelaire turned his attention to some early nineteenth-century fashion plates. He described them as attractive and cleverly drawn and considered them as capable of revealing 'the moral and aesthetic feeling of the time'.[69] In effect, he offered them up to the painter as a source of modern style, as a possible substitute for the canonical models of the Academy: 'These engravings may be interpreted as beautiful or as ugly; if ugly, they become caricatures; if beautiful, they are like antique statues.'[70] The 1860s witnessed the high tide of Second Empire elegance; one barometer of this phenomenon is the great popularity of fashion magazines, and it is possible that Monet, with the sanction, so to speak, of Baudelaire, turned to these illustrations as graphic sources for his art.[71]

In the initial stages of his project his greatest concern was with *plein air* – with working in nature in order to capture its specific and elusive qualities – and he pursued his studies in the forest, of the landscape setting and individual figures, as long as he could. But, as

23. Detail of
left-hand
fragment [4]

his experience with Bazille indicates, and despite the willing cooperation of Camille, Monet could not depend entirely upon live models for developing his group composition. It is in this connection that fashion plates, along with clues offered by Manet's *Déjeuner sur l'herbe* and eighteenth-century painting, may have played their role.[72] Contemporary fashion plates provided an admirable repertory of figures and groupings, devoted as they were to the presentation of apparel to be seen from the most advantageous

24. X-ray photograph of 23

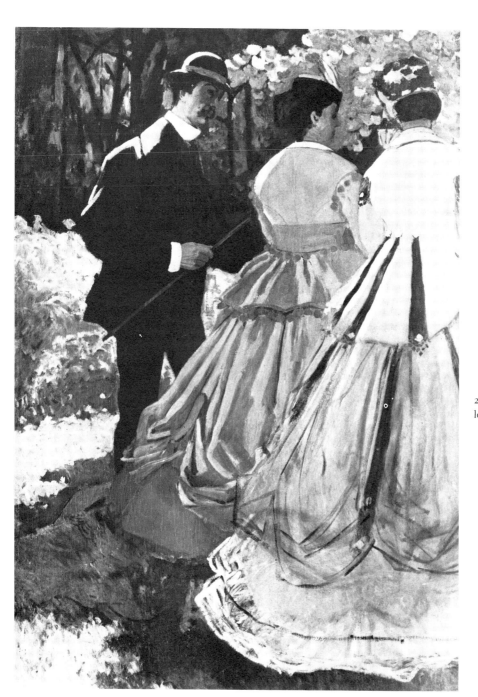

25. Detail of
left-hand fragment [4]

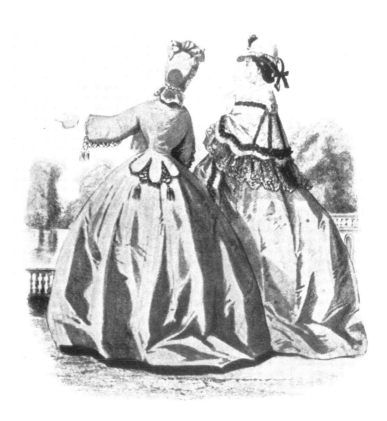

26. Fashion plate from
Les Modes parisiennes, 1863

viewpoint. Fashion illustrators presented figures in various
postures – standing, moving, seen from the front, side, and rear, in
full and three-quarter views [27]. The various poses which Camille
struck for Monet as she modeled for the painting may have been
determined by her familiarity with these plates, and indeed Monet
probably knew of them through her.

Monet's involvement with the fashion plate during preliminary
stages of work on the *Déjeuner* – when he had to develop his ensemble
with Camille as his only dependable model – is suggested by the
charcoal sketch of the picnic group [32]. The two standing women
to the left, in the prominence of their costumes and almost tell-tale
stiffness of their poses, could have been drawn directly from these
illustrations. They retain their sense of derivation from such a

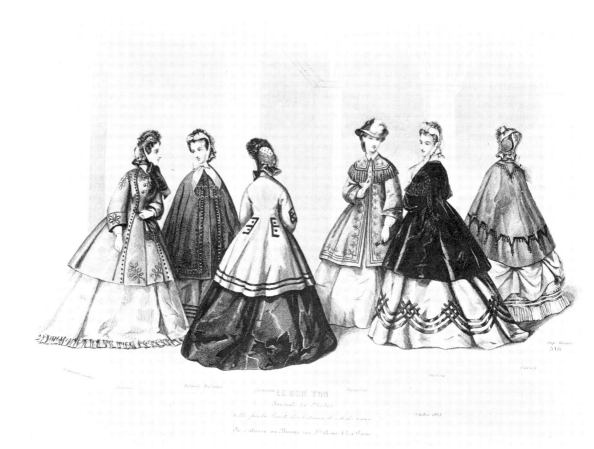

source through their subsequent transformations in the Moscow sketch [3] and final painting [25].[73] When, in March 1866, Monet produced in four days his Salon portrait of Camille [12], he again may have turned to the fashion plate or to contemporary magazine illustrations; at any rate, he had his model assume a pose which was ubiquitous in such works.[74] Monet's next major painting, the *Femmes au jardin* [45], still more strikingly conveys a sense of his preoccupation with such pictorial sources. In general conception as well as in the treatment of individual figures, in the garden setting as well as in the somewhat wooden poses, brittle drawing,

27. Fashion plate from *Le Bon Ton*, 186

and pattern-like handling of light and shadow, the painting seems to reach an accord with the fashion plate. The inherent modernity of the commercial product was recognized by Baudelaire and, it would appear, by Monet, as consistent in subject and form with the principle of contemporaneity with which the modern artist sought to align himself.

Monet's turn toward contemporary life as the subject of his large painting was bound up with his growing interest in the work of Courbet and Manet, the two artists who now came to replace Boudin and Jongkind as the primary influences upon his artistic personality. Courbet's *The Painter's Studio* and *Burial at Ornans* serve, by reason of their modern iconography and great size, as prototypes for Monet's gesture in creating a contemporary scene so large that it could not be construed as anything but a challenge to academic precepts of propriety. It is easier to link Monet's *Déjeuner sur l'herbe* to Courbet in terms of shared attitudes than in terms of painting, however; with perhaps only one exception, Courbet's oeuvre does not stand as an important stylistic source for the *Déjeuner*. One may recognize, it is true, in the rough brushwork of the *Burial* in particular and in Courbet's later use of the palette knife generally, an important precedent for the marked emphasis upon the materiality of the pigmented surface in Monet's painting. In this respect, Courbet plays a significant role in preparing the way for the renewed accent placed upon the plane of the canvas in the painting of the 1860s. But Courbet's direction during that decade was away from the impressive barbarism of his earlier paintings toward an even greater stress, in his major works at least, upon the finely polished, continuously modeled forms associated with academic painting. Monet and his friends recognized this; by 1867, when Manet and Courbet mounted their independent retrospective exhibitions in Paris, the latter was roundly criticized for having retreated from his earlier independent position.[75] If one returns, however, to the 1850s, one finds a single canvas, the *Demoiselles des*

bords de la Seine [28], which offers a striking precedent in subject, handling, and palette for Monet's *Déjeuner* and subsequent paintings like the *Femmes au jardin*.[76] The *Demoiselles* has an idyllic content similar to that of Monet's *Déjeuner*; it is a scene of leisure in the open air with no dramatization or mythicization attached to it. The woman in the foreground is clearly delineated and firmly modeled, yet her filmy bodice and the sleeves of her dress display a delicate transparency. The palette is relatively bright with pure spots of red and yellow keying up the greens of grass and foliage. The latter, the leaves of the trees in particular, are painted with extraordinary clarity, each leaf treated almost as a unit distinct from its neighbors. Similar elements, but carried much further in the direction of brightness, flatness, and linearity, are found in Monet's *Déjeuner sur l'herbe* and *Femmes au jardin*. The *Demoiselles des bords de la Seine* stands out from Courbet's work as a major antecedent of, and possibly a direct stimulus to, Monet's later essays.[77]

From 1864 to 1866, Monet's activities in Paris were for the most part confined to the left bank, in the neighborhood in which Courbet maintained his studio on the rue Hautefeuille. His move to the Batignolles quarter reflects the direction which his work was taking at the time. To shift from the Latin Quarter to the Batignolles was, in 1866, to move from one sphere of influence to another, from the fading realism over which Courbet presided to the burgeoning spirit, which has no name, most powerfully evoked in the art of Manet. Unlike Courbet, Manet played no part personally in the creation of Monet's *Déjeuner*,[78] but his art was of key value in stimulating the project, and Manet's tendencies as an artist were those to which Monet came to show an increasing affinity. In turning to Manet's work he chose precisely those examples which approximated his own developing interest in modernity and open-air themes.

The *Musique aux Tuileries* [15], exhibited at the Galerie Martinet in February 1863, was Manet's major exercise to date in a genre which coupled contemporary subject matter with a natural setting.

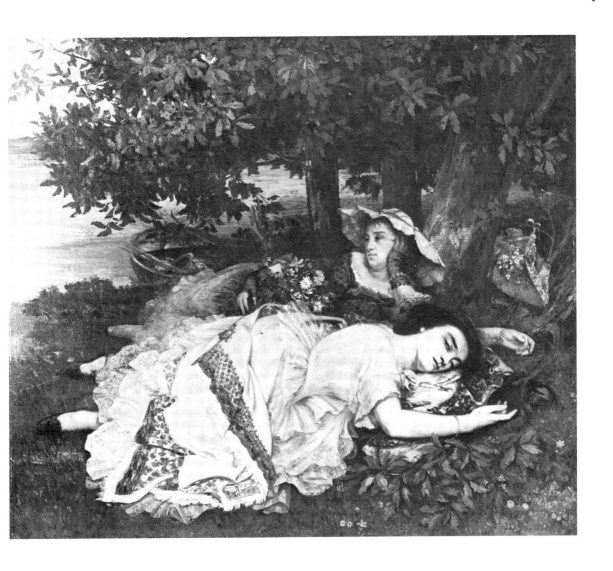

28. *Les Demoiselles des bords de la Seine*, Gustave Courbet, 1856

In the somewhat harsh insertion of reds, yellows and blues into an otherwise gray and verdant harmony, and in the summary crudeness of its definition of form, Manet seemed to second the statement which Courbet had made in the *Burial* and hint at the direction which a modern style might take. Monet did not fail to note this, and, in the Moscow sketch for the *Déjeuner* [3], there are echoes – notably in the red and green accents at the lower right and in the somewhat roughly hewn figures – of the coloristic and formal treatment in Manet's *Musique*. Manet's *Déjeuner sur l'herbe* [14] exhibited three months later at the Salon des Refusés, provided a more precious and provocative expression of a related theme. Though the painting was immersed in a more conventional coloristic context, the notoriety which it received upon its exhibition was sufficient to make it Monet's primary focus for the major work which was being formed in his mind.

Actual references to Manet's painting are few, however. That Monet was thinking of it in the early stages of his project is suggested, nevertheless, by details of the charcoal drawing of the ensemble [32]. The drawing, in its grouping of figures, is much more reminiscent of eighteenth-century *fêtes champêtres* than of Manet's *Déjeuner* or of the relief group of the *Musique aux Tuileries*. But the stooping figure at the far right of the drawing bears a distinct resemblance to the bathing woman in Manet's *Déjeuner*. The pose of Monet's figure is almost identical to Manet's, though reversed. She even seems to be bathing as her feet are cut off by horizontal strokes which appear to represent water, and, as in Manet's painting, she is isolated from the main group of figures. There can be little doubt of the reference to Manet in this instance; other, though less certain, links may also be noted. The seated male figure at the left, peering out from behind the two standing women in the foreground, borrows the position and glance of the seated Victorine Meurent in Manet's *Déjeuner*. The figure in the right foreground with legs outstretched is a not too distant relative of the right-hand figure in the Manet. In the rear center, behind the spread-out picnic cloth,

a reclining figure is sketched in, its arms raised to cushion its head. This somewhat bizarre figure, perhaps nude – it is uncertain – may be a freely associated reference to Manet's *Olympia*, which was just then being exhibited, to great outcries from the critics and public, at the 1865 Salon. If it does not correspond precisely to the pose of Olympia herself, it is almost identical, although once again reversed, to that of Goya's *Naked Maja*, which was recognizably an ancestor of Manet's painting. Reminiscences of Manet's *Déjeuner sur l'herbe* were not eliminated completely as Monet's painting developed. In the final version – in the central fragment [2] – the prominence of the still life (for all that it is a standard element in paintings of this genre) recalls the similar emphasis in Manet's painting, and the newly installed seated figure, resembling Courbet, is in pose a combination of the two left-hand figures in the Manet.

Beyond the work of Manet and Courbet one cannot find close precedents for Monet's picture in mid-century French painting. Picnic scenes were not unheard of, but rarely did they remove themselves so effectively from the realm of the anecdotal or the picturesque. The forest scenes of Diaz or Monticelli, peopled with young ladies in elaborate costumes, were generally small-scale depictions of courtesans or of mythological subjects, rather than

29. *Le Déjeuner sur l'herbe*, James Tissot, mid 1860s

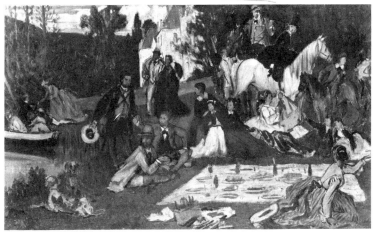

picnics. If large in size, a painting would tend to depict a specialized situation, such as the world of the Empress in Franz-Xaver Winterhalter's *Empress Eugénie and the Ladies of her Court*, which figured prominently at the 1855 Salon, or the traditional genre of the hunting picnic, essayed, for example, by Courbet himself in his *Repas de chasse* of 1858.[79] It was only in the 1860s that scenes of everyday life came to be treated on a scale previously associated with grand themes. Picnic scenes, specifically, tended to remain small, geared to the purse of their prospective middle-class audience. Bazille's *Repos sur l'herbe* [10] and James Tissot's small *Déjeuner sur l'herbe* of the middle to late 1860s [29] would seem to be representative examples, as is Tissot's *Partie carrée* of 1870, a somewhat larger costume piece emphasizing, as did English *genre* of the period, the anecdotal or flirtatious aspects of the pleasurable gathering.[80]

The thematic and formal fabric of Monet's *Déjeuner sur l'herbe* was woven from the major strands discussed in the foregoing section. Of greatest importance were his desire for modernity, stimulated by the ideas of Baudelaire and others; his resolve to make his mark forcefully, as a modern artist, within the institutional structure of the Salon; the stimulus of the personal and artistic example of contemporaries, such as Courbet and Manet; and his devotion to nature, which guided his initial conception of the subject as well as the earliest studies carried out *en plein air* in the forest of Fontainebleau. His initial sense of fidelity to the natural setting placed an indelible stamp upon the project, and it shows through the subsequent transformations the painting underwent. In the course of work the scene of Monet's operations was shifted from the open air to the studio. There the final conformation of the project was being determined when he was forced by economic circumstances to abandon work on the definitive canvas.

4. Studies and Sketches

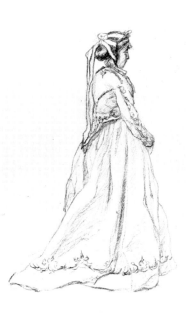

30. Sketch of Camille,
Claude Monet, *c.* 1865–6

Monet's letters to Bazille, written from Chailly from April to mid-August 1865, attest to a constant preparation for the projected large painting during that period. Very few preparatory works remain, however, to illuminate his process. The three views of the Bas-Bréau road mentioned earlier (see illustrations 7, 8, 19) establish the setting to which Monet intended to adapt his figures. This is revealed by the charcoal sketch [32], where the characteristic fleeing perspective of the road and its bordering trees, as one finds it in all three Bas-Bréau paintings, is seen once again. In the end, however, he seems to have shifted his attention to the side of the road; the large tree at the right retains its prominent position, but the open view of sky between trees has been eliminated.[81] None of the figure studies of Camille, with which Monet occupied much of his time while awaiting Bazille's arrival, has survived. The drawing of Camille standing in profile [30] shows her wearing the same dress which appears in the Washington and Moscow paintings. But in pose and type of hat this figure is closer to the woman standing at the left in the *Femmes au jardin* [45], which was not begun until the following spring.[82] The drawing, therefore, may have been done anytime during the period from spring 1865 to spring 1866.[83]

Of the three Bas-Bréau landscapes, two figure paintings, and three drawings which relate to Monet's activities at Chailly prior to work on the final version of the *Déjeuner sur l'herbe*, only the painted sketch [31] in which Bazille appears with Camille, can be dated with certainty after Bazille's arrival. The two drawings of the ensemble may have been sketched before Bazille came to pose. Even the Moscow painting [3] may have been started before his

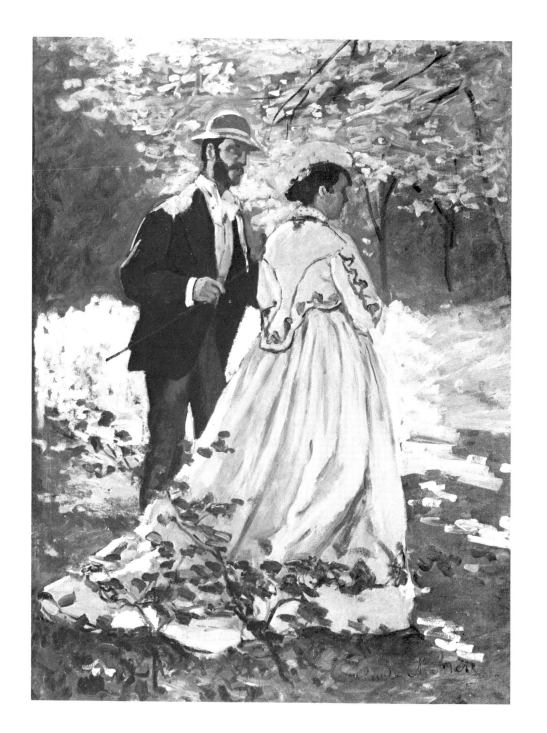

31. *Bazille and Camille
study for 'Le Déjeuner sur l'herbe',*
Claude Monet, 1865

arrival, but for the most part it reveals Monet's dependence upon
his friend's aid, for Bazille appears in four places in that work: at
the left, standing in the rear center, outstretched in the right fore-
ground, and standing with his back against the tree at the right.[84]

The Washington sketch [31] may be considered as typical of the
undoubtedly larger number of preparatory studies which Monet
made in the forest. The figures are established somewhat roughly
before an even more brusquely painted landscape. The broad,
rapid, prominent brushstrokes of the grass, foliage, and sky yield
in the figures to a slightly more deliberate manner characterized
by blocky areas of color such as the highlight on Bazille's right
shoulder, by the faceted modeling of his head, and the simple,
flattened rendering of Camille's face. The figure of Bazille is stiff
and awkward in pose. The tonality of the whole is rather dull, the
overall effect is grayish; the blues do not reach toward the pure hue
and the flesh tones are almost brown.

Monet's method of utilizing his small, painted sketches is
indicated by the way he transferred this isolated study to the
ensemble of the Moscow painting. There the figure of Camille is
overlapped by another, transforming the couple into a new unit
of three at the left. The gray-clad Camille in the Moscow version is
almost identical with the figure in the earlier sketch. Bazille's figure
has been slightly altered in details and in general stance; the tense
attitude of leaning forward, seen in the Washington study, is
relaxed somewhat in the Moscow canvas. His suit seems more
clean-cut, his cuffs and collar more highly starched. The highlights
on his hat and body are bluer, and a red hat band adds a coloristic
sparkle to the still sombre group.[85] These changes are slight; Monet
seems to have depended heavily on sketches such as the one in
Washington for arriving at his final large sketch, the one which was
to serve as the model for the monumental canvas destined for the
Salon.

The Moscow sketch [33] is a development from the charcoal
drawing of the entire group of picnickers [32]. In the drawing, the

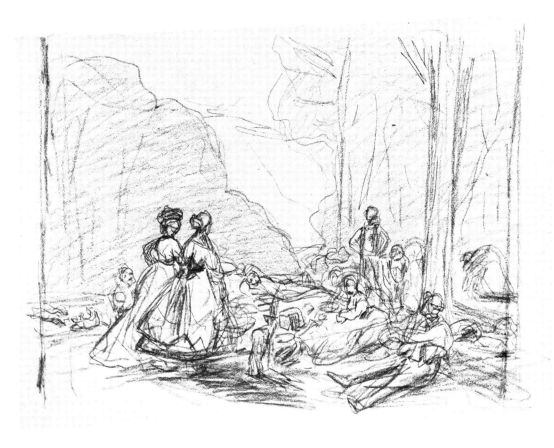

Bas-Bréau landscape setting is clearly indicated, and the position of the tree at the right has been fixed. The large, lozenge shape of the picnic cloth, with its still life, and the dog in the foreground are established in what was to be their final positions. But the placement of the figures has not been settled as yet. The two women at the left, the man seated against the tree in the right foreground, the woman just to his left, seated on the cloth, roughly correspond to their future roles in the Moscow canvas. The seated figure whose head and upper body appear at the left behind the standing woman seems to be a preliminary version of the seated man, fourth from the left, in the painting. The drawing has fewer figures than the painting, nine as against twelve. It is also closer to square in format

32. Study for *Le Déjeuner sur l'herbe*, Claude Monet, 1865

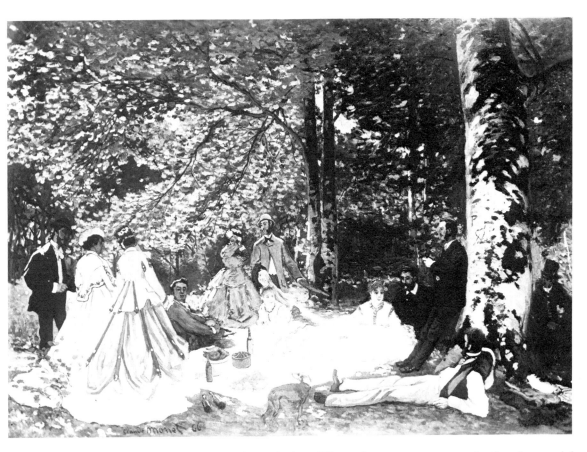

33. Sketch for *Le Déjeuner sur l'herbe*,
Claude Monet, 1865–6

than the painting. These factors account partly for the spatial
distinction between the two versions. In the drawing the group is
compressed toward the center, and the figures are so arranged as
to lead toward the vanishing point where the two masses of trees
meet at the horizon. There is, in the drawing, for all its sketchiness,
a clearly calibrated spatial recession, a sense of the artist's firm
control of a complex organization. In the Moscow sketch [33] the
gap between the trees is filled in and a generalized backdrop of
foliage reduces the flow into depth. Diminution in size of the back-
ground figures is not stressed, as it is in the drawing, and the forces
which would lead to a vanishing point are caught up in the vertical
figure of Bazille and the tall, double-trunked tree in the rear center.

The figure group now spreads across the foreground in more random fashion, reflecting the horizontal format of the canvas and resembling Boudin's crowds on the beaches at Trouville and Deauville or, to a lesser extent, the throng which fills Manet's *Musique aux Tuileries*. Although a sense of depth is retained, largely through the contrast between the figures and the dark ribbon of tree trunks behind them, the approach is toward a relief space, more limited than the perspective thrust of the earlier drawing.

The Moscow sketch brings together Monet's researches of the previous months. The painting reveals, however, that in assembling and juxtaposing his outdoor studies, he did not confine himself to work in the studio; the canvas, despite its four-foot by six-foot dimensions, was undoubtedly worked on outdoors as well. If Monet did not carry it the mile and a half to his chosen site in the Fontainebleau forest, he must have posed his figures under similar lighting conditions near the inn at Chailly where he was staying. The painting, as one sees it today, displays a tonal veracity and a delicacy of nuance which can be explained in no other way than by assuming a process of painstaking observation and execution directly before the motif. Not Boudin's gray harmonies, not Jongkind's bitumen-grounded seascapes, not the value-oriented canvases of Courbet and Manet, not Monet's previous work, prepare one for the variety of tonal and coloristic description to be found in the Moscow sketch.

The setting is characterized by a verdant grayness which emits a sense of subdued sparkle, of air circulating through the leaves and among the group of picnickers. Sunlight is filtered through the canopy of trees above. It falls most directly upon the orange-ochre-clad woman third from left in the foreground and in bright patches upon the picnic cloth and two seated women in the center. It is in this latter area, dappled with sunlight and mild shadow, that one finds the most varied and yet most unified passage within the painting. The handling of the still life is rich yet subtle. The fruits exhibit a range of tones which reveals the all but fanatic intensity

that characterizes Monet's scrutiny of the scene: ochres, near yellows, grayed yellows, dulled gray-greens, grays, off-whites, violet, blue, a touch of scarlet – modified, subdued, and related to the darker but comparably nuanced shades of the wine bottles and other objects. The standing bottle at the left edge of the cloth is composed of a dark brown, dark blue-gray and gray-green, deep russet, a cap of pure vermilion. It is placed before a loaf of bread, a blend of ochre, grayed pink, and grays. The picnic cloth is of a middle neutral gray and a strong white, which conveys the brightness of the sunlight falling upon its surface. The arm of the central seated woman is as gray as the plate (very slightly yellowed) which she holds out. The fabric of her dress, trimmed and spotted with dark gray and black, ranges from white through light to middle gray. A few strokes of light blue key up the mauve pink – heavily painted but judiciously chosen – of the flesh tones which show through the thin material of the bodice. Her face is a flat grayed tan, her hair a darker, richer brown.[86]

The woman seated to her left (our right) turns away from the light which spatters the picnic cloth; touches of white creep up from the cloth and meander across her pale green skirt. Her dress, accented with stripes of a mid-green, becomes grayer as we move from left to right. The pink flesh of her upper body, revealed through the dress, is correspondingly grayed; her right hand is also gray, of the same value and almost the same hue as the skirt on which it rests. Her face, in shadow, is almost violet as it partakes of the muted colorations of the area in the immediate vicinity of the tree trunk at the right. Monet's sensitivity to the perceived suggestions of the intensity and distribution of light is extraordinary. It is evidenced in areas of darks as well as lights. The sombre costumes of the men seated, standing, and stretched out around the tree are varied in terms of black, gray, and brown, warm and cool. The tree trunk responds to its environment by gathering in almost all the colors of the neighboring figures: grays, dark browns, mauves move up its height, becoming darker and more violet as they ascend. In

the lower right corner an intense green and a bright vermilion
provide a sudden change; the latter hue calls across the canvas to
the red hat band of Bazille standing at the extreme left.

The Moscow sketch reveals a probity of observation and dexterity
of painterly execution which were all but unprecedented in 1865.
No artist in Monet's circle practiced the vocation of *plein-air*
painter as strictly as he did, nor did anyone interpret his task with
such profound understanding of its requirements. He knew that he
must see everything, not only costume and movement, not only
value shifts and striking colorations, not only the color of shadows
and the decolorations caused by bright light, but all these things
together in their minute variations and in their interrelationship.
He understood, too, the character of his perception, that he was
concerned with appearances, with suggestion, with breadth as well
as detail. He could not consequently consider, for example, the
minute finitude of the Pre-Raphaelites, to that date perhaps the only
artists who had demanded of themselves as high a degree of
veracity in observing and recording nature, as representing a
viable mode of painting. As a modern French artist he was certainly
aware of the close relationship between personal observation and
the free sketch, and of the value of the broad, and even crude, as a
measure of artistic truth and independence.[87] The painting in
Moscow thus reveals a combination of tonal delicacy and a summary
description of form; it testifies to the accuracy of Monet's eye and
the controlled strength of his hand. It stands as well as a testament
of Monet's faith, at this stage in his young career, in the validity of
nature as an end worthy of the total commitment of the artist's
resources.

34. Detail of Moscow sketch [3]

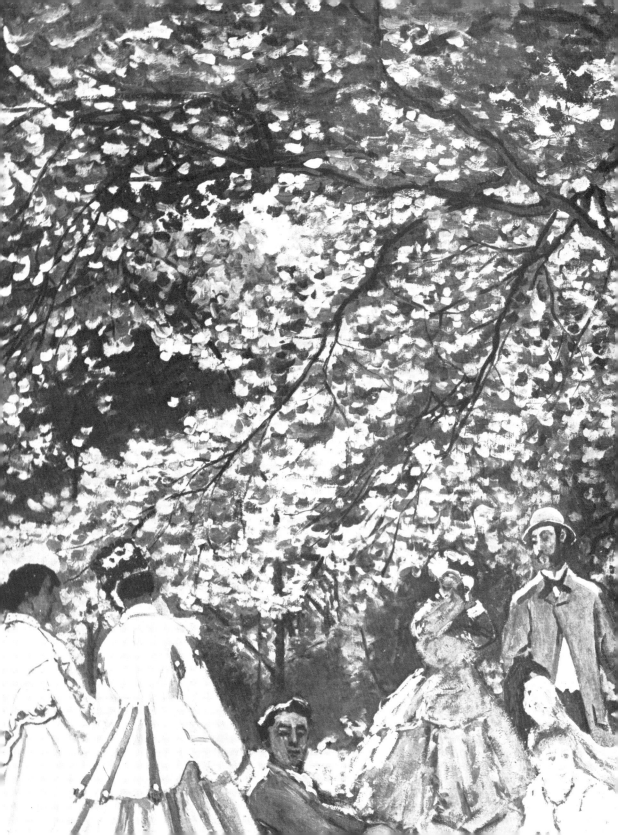

5. The Final Version

The Moscow sketch, as it stands today, is a work complete in itself, and yet it was meant to serve as only one stage in Monet's larger enterprise. It provided the basis for his fifteen-by-twenty-foot version of his project, which he worked on in Paris from the fall of 1865 through April of 1866. Sometime during that period, he undertook to alter aspects of the final canvas while keeping the general organization of the sketch. Upon analysis, these changes prove to be of the utmost importance. A comparison of the Moscow painting with the two existing fragments of the final version of the *Déjeuner sur l'herbe* [2, 4] indicates the direction in which Monet was moving at the point where he was forced to abandon the costly project.

The unfinished state of the central and left-hand sections of the large canvas reveals that Monet was actively at work on it, in process of making some changes and contemplating others, until the very end. The central fragment [2, 35], as we see it today, shows one major shift from the Moscow painting. The seated male figure, fourth from the left in the Moscow canvas, has been transformed in pose and appearance. As was mentioned earlier, the altered features and bulk of this personage give him a distinct resemblance to Courbet. This figure is completely finished except for his left hand, which is barely sketched in. Earlier a further alteration in the central group could be discerned. This central portion of the painting, when it hung on Monet's studio wall, was larger than it is today; it was mutilated further sometime after his death, possibly at the time it left his studio to enter a private collection. A photograph taken at Giverny [1] shows a section on the right which includes a seated woman in a flat toque placed roughly and indecisively in the same spot where we find the seated woman in the green striped dress in

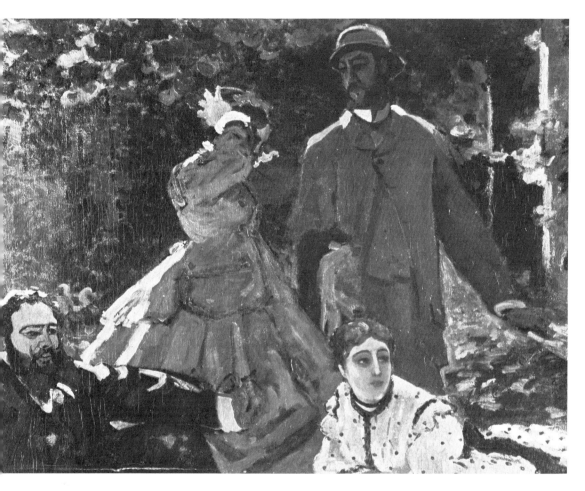

35. Detail of central fragment [2]

the Moscow sketch. Apparently in order to eliminate this un-resolved passage, a strip approximately one-foot wide was cut away.

The alterations in the Jeu de Paume fragment are both more explicit and more revelatory. Costume, palette, and scale of figures (effected by a shortening of the women's skirts at the bottom) have been revised in relation to the corresponding portion of the Moscow sketch. The man and two women at the left of the latter painting were initially transferred directly to the large painting, as the X-ray examination has confirmed. Monet, in the course of reworking the final canvas, altered these figures. The

pentimenti are for the most part clearly discernible to the naked eye (compare illustrations 23 and 24).

In the right-hand figure there is no change in palette or costume, but the length of the dress has been reduced about four inches, and an irregular brown line, sketched in about three inches above the present termination, would seem to indicate a proposed further shortening [36]. The scalloped edge of the tan overskirt has been shortened correspondingly. Monet was apparently preoccupied with reducing the length of the dress to match the more assured

36. Detail of left-hand fragment [4]

alterations in the costume of the figure in the center of the group of three. This latter figure has been reworked with greater finality. The length of her skirt has been reduced about eight inches, and the entire costume has been changed. In the place of the gray flowing dress with its long train trailing over the grass and cut off at the edge of the canvas, we find a warm gray, almost brown, costume punctuated by areas of trim, and an underskirt of a bright, flat vermilion hue. The dress is not only reduced in size but seems more self-contained, describing more emphatically the shape and size of the figure within it. Similarly, the large, plumed hat, seen in both sketches, is replaced by a small flat toque with a neat little pointed feather. The changes in the hat and dress lead in the direction of a more simplified, more precise interpretation of form. The linear trim on the earlier gray dress has been replaced by the unit areas of bright red, varying in size and shape from the round pom-pons to the broad sash at the waist to the unbroken area of the underskirt. The change in palette is marked. The dull gray of the earlier version has given way to the richer warmth of the almost brown dress and to the bright, pure hue of its decorative embellishments. In response to this major color change in the central figure, the red band on Bazille's hat in the Moscow sketch has been replaced in the new version by a cool blue one. Other changes in the Bazille are slight, but, as in the central figure of Camille, they are in the direction of a neater presentation: his beard has been removed, and his flowing white necktie has been replaced by a thin black one.

The modifications of costume and proportion in the final version of the *Déjeuner* suggest insights into Monet's aims in the latter stages of his work on the painting. In so far as the costume changes respond to shifts in fashion which accompanied the progress of his work, Monet was being faithful to Baudelaire's strictures on the importance of observing accurately the costume of one's own time. But were these changes in dress also complementary to a larger concern upon the formal level of investigation? There can be no doubt that they coincide with the stylistic direction which the work

was taking. In the final version of the *Déjeuner*, Monet effected a revision in technique, in spatial definition, and in the means of achieving the decorative, surface unity of his canvas. Both the remaining fragments are characterized, in comparison with the Moscow sketch, by a crystallization of color areas and a clarification of contours. Color is enhanced in purity and intensity and each area of color establishes a shape or is placed carefully within bounding contours. Each leaf on the trees is a separate touch of green, each figure clearly delimited and easily grasped visually in terms of its silhouette. Monet's manner of firming up his shapes is graphically revealed by a comparison of the seated woman holding out a plate as she appears in the Moscow painting [37] and in the central

37 (*below left*). Detail of Moscow sketch [3]

38 (*below right*). Detail of central fragment [2]

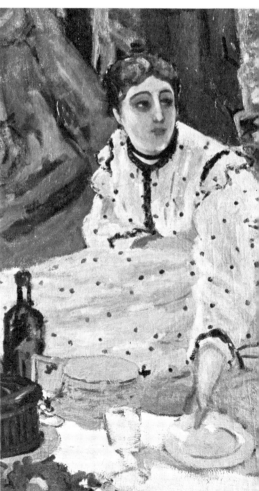

fragment of the large canvas [38]. The fresh, winsome, seemingly newly washed visage of the girl in the sketch is replaced by a woman's face distinguished by its precise *maquillage*. The shape of the face is a clear oval, the hair is like a separate, adjoining area. Even the lights within the hair are clearly differentiated from the darks. The features are defined by firm lines which also serve to establish divisions for changes of tone within the face. Her dress is semi-transparent, and Monet carries over from the Moscow sketch his exploration of the visual delicacy of flesh beneath a filmy material. But once again, the pink-tinted areas are made more assertively clear as shapes within the larger shape of the woman's upper body and arm. Monet's final canvas is devoted to precisely this kind of bold transformation. That which in the Moscow sketch conveys the sense of irregularity, of nuance, even of spontaneity, is pinned down and regularized; nature, originally observed in its subtlety and variety, is fixed grossly and firmly upon the canvas.

The modifications of form in the final version of the *Déjeuner* serve to establish an effect of deep space which is more emphatic than in the Moscow sketch. In the latter [33] the bottom terminations of the figures are rather indifferently designed. Along the surface, from left to right, a meandering contour casually links the skirt endings, the near edge of the picnic cloth, the dog, and the out-stretched figure of Bazille. The group spreads across the entire width of the canvas, making contact with, and being cut off by, the frame at either side. The effect is to emphasize the relief grouping and surface organization which Monet introduced in preference to the greater stress upon spatial depth in the large charcoal drawing [32]. In the later stages of his project, however, Monet seems to have returned in part to his earlier conception.

The alterations in costume, scale, and palette, and the clarification of contours visible in the Jeu de Paume fragment succeed in turning his figures into depth. They are no longer attached to the frame or calligraphically linked upon the surface. The formerly ragged endings have been replaced by clean, curving arcs, which impart to

the broadly painted figures a sense of cylindrical, volumetric substance, and these volumes are clearly placed one behind the other, stepping back into the landscape. (The change from the Moscow sketch is so firm and so clearly intended to enhance the spatial effect of the painting that one may assume similarly directed changes were introduced in the lost right-hand section.) The central figure of Camille in the left-hand fragment is particularly instructive of Monet's intention [40]. She no longer interacts with the setting as she does in the Moscow sketch [39], where, at bottom left, the twigs and leaves of the plants play decoratively across her skirt, joining with it and assuming a calligraphic function similar to that of the linear pattern on her bodice and sleeve. In the final version she is seen as separate from the landscape; instead of being graphically linked *with* it, she assumes a new position, spatially, *within* it.

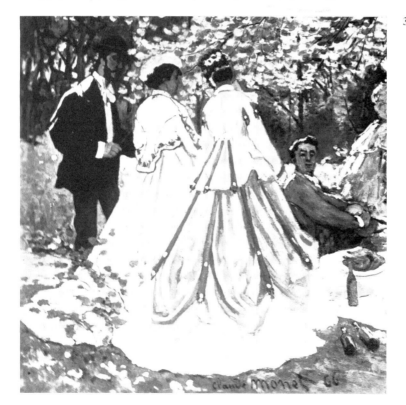

39. Detail of Moscow sketch [3]

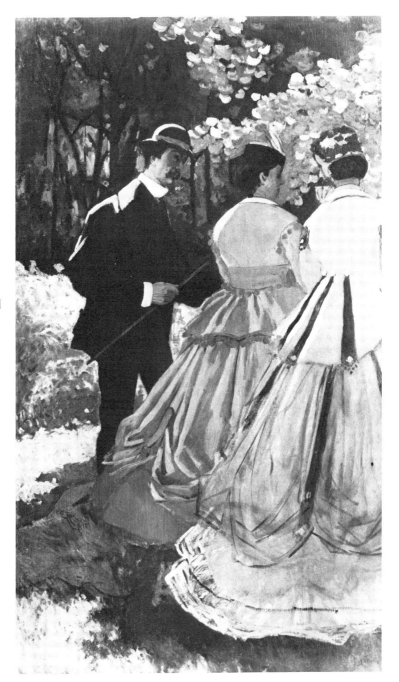

40. Detail of left-hand fragment [4]

Details of her new costume abet the shift toward volume and depth; a sash which goes *around* her waist and a small, round hat replace the rear portion of the figured vest and the plumed hat of the Moscow version, both of which are directed along the surface, outward and downward to the left. The revisions in palette, too, are consistent with the spatial change; within the group of three figures at the left the progression is from yellow to red to blue, directed back into depth. In response, the forest setting – the foliage overhead, the receding dark ribbon of the tree trunks behind the figures – takes on a more active and meaningful role as a three-dimensional living space in which the figures are disposed.

Monet was primarily concerned with establishing his figures within the landscape, necessitating that they be freed of the frame which, in the Moscow sketch, helps to bind them to the surface. Thus the left-hand fragment exhibits more striking alterations than does the central section. But in the center fragment as well [2], revisions which are consistent with the spatial reorganization of the left-hand portion may be observed. The perspective of the still-life objects upon the cloth has been altered ever so slightly, but sufficiently to improve their placement in space. This may be seen in the rearrangement of the bottles and bread at the left of the cloth and in the more secure positioning of the wine bottle *behind* the *pâté* in the rear center of the still-life group. The dog in the foreground has been eliminated, opening up the center and inviting our entry into the picture. In this connection even the more open, welcoming gesture of the Courbet-like figure may be of significance.

In attempting to place his figures firmly in depth, Monet did not relax his grip upon the decorative unity of his canvas. Rather, perhaps in response to the huge scale of his painting, he altered his approach to this problem, substituting a system of related, block-like areas of color and clearly circumscribed forms for the more calligraphic linkage established earlier. In what is perhaps the most striking aspect of the final painting, the solid chunks of color which he employed for his highlights, Monet accomplished a double

41. Detail of left-hand fragment [4]

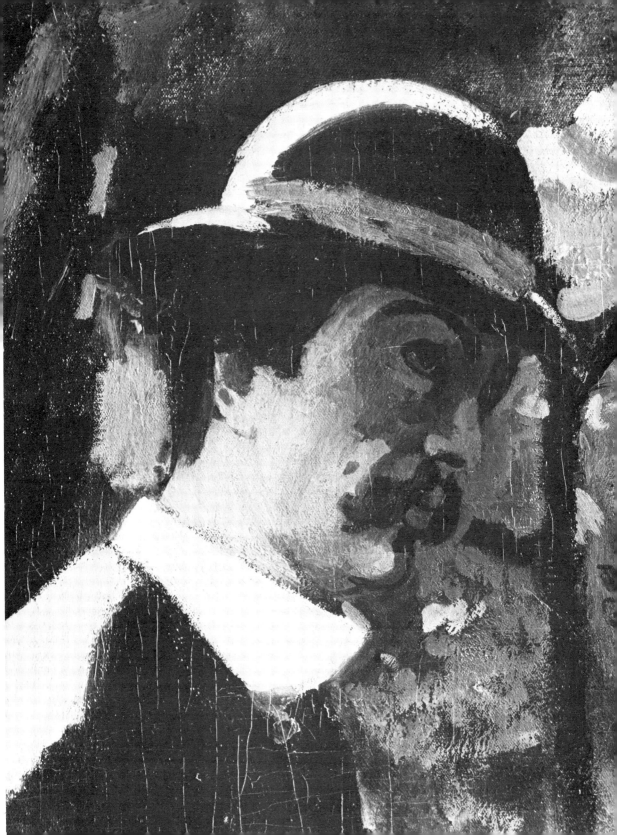

purpose, consistent with his simultaneous concern for depth and surface: in the patches on the shoulders of his figures, for example, he established a faceted, slab-like modeling of form; at the same time the patches serve as large decorative areas of color, very much in accord with the bright, flatly rendered vermilion accessories of Camille's new dress and with the increased clarity of silhouette of the figures. Monet employed such highlights in his earliest sketches for the project. But, in the course of his work, he came to define their shapes more clearly and to intensify their color. In the Washington sketch the patch on Bazille's shoulder is a blue-gray; in the Jeu de Paume fragment the color has been altered to a bright, pure blue, and its shape has been clarified. It takes on an insistent quality of its own, assuming a semi-independent relationship to the larger form of Bazille's body [41].

In the final version of his painting, Monet imparted to his highlights and to such intangible elements as the sky an exaggerated materiality. Thus Germain Bazin has been prompted to marvel at 'those enormous lumps of cobalt by means of which the sky literally pierces the foliage'.[88] Both sky and leaves are treated as bold splotches of pigment; they assert their own coloristic and physical qualities almost as much as they serve a descriptive function. Monet developed a network of heavily pigmented color areas which could be apprehended independently of the objects they help to describe. Thus the spots of sunlight upon the picnic cloth may be perceived as assertive, abstract shapes, floating above the cloth itself. In a sense the sun becomes the generator of abstract forms within the painting. Away from the variegated experience of nature, working from sketches in his studio, Monet came to treat sunlight as a fixed element. In the final version of the painting the highlights upon the costumes of his picnickers and the dappled areas of light distributed over the forest floor join with the chunks of blue sky, the dabs of leaves, and the carefully circumscribed large forms of the figures to create a decorative unity and a surface consistency which binds the ensemble together upon the plane of the canvas.

During the winter and possibly into the spring of 1866 Monet subjected the final version of the *Déjeuner sur l'herbe* to an intensive program of modification. His initial conception of an open-air group of figures in contemporary dress, engaged in a casual, leisure activity, developed into a major statement of artistic intentions in the mid 1860s. His efforts finally crystallized into the bravura attempt to create a highly colored, life-size, strikingly stereometric image which went well beyond the developed statement of the Moscow sketch. It was meant to be, in its scale and in its convincing representation of volumes seeming to exist in space, like a continuation of our world.[89] In this he brought to a climax both the Renaissance tradition of pictorial illusionism and the tradition of realism which such a pictorial conception implies. But should we be tempted, figuratively, to enter the painting, the tremendous artificiality of its rendering would strike us with full force. Nature is not made of the same substance; it is not composed of such lines and blocks of color as we find in this painting. Monet, in clarifying his composition and structuring it in depth, also increased its decorative unity. By crystallizing his forms and emphasizing his contours and translating the fall of light upon objects into a system of semi-independent blocks of pure color, he succeeded in creating a surface of an insistent materiality and of imaginative, abstract inventiveness. In attempting to rival Manet's museum-inspired *Déjeuner sur l'herbe* with an open-air interpretation he succeeded in achieving a rendering of an equivalent artificiality.

6. The Project and its Implications

Monet's *Déjeuner sur l'herbe*, from its inception, was intended to be a great work of art, but it is not at all clear that, originally, the artist envisioned as complex and problematic a statement as the painting ultimately made. Initially he conceived of a painting which would state a vital principle of thematic contemporaneity as fully and logically as possible. Hence his choice of a modern subject, his fidelity to precise observation of that subject, out of doors, and his choice of scale, of a one-to-one relationship in size between his painted figures and their living models. His growing exasperation during the months in which he begged Bazille to pose for him and the evidences of fanatic dedication to appearances in the Moscow sketch attest to his desire for truth and conviction. As the final canvas developed, however, he moved into a more complex area of stylistic exploration. He had to forsake the *plein air* which had been the chosen and necessary arena for his initial studies. Away from the motif, he was forced ultimately to make decisions based not upon immediate visual sensations but upon the process of statement and revision which accompany prolonged work in the studio. It was at that stage, after he had left nature behind him, that Monet's most radical innovations were made.

His work gradually came to exhibit concerns opposed to his initial desire for naturalism. The analysis of nature's data gave way to the synthesis of form and color. Monet's painting assumed an increasingly artificial aspect: colors, as in the Jeu de Paume fragment, were heightened in intensity and purity and, necessarily, spread over larger areas, reducing the sense of accommodation to a governing atmospheric situation; atmosphere became hard and clear; figures came to be more firmly defined, losing their suppleness and emerging as stiff mannequins; highlights and dappled sunlight

were crystallized in shape, appearing almost as pennants pinned to the canvas. Monet sought, in his final version of the project, to create a painting by reinterpreting the traditionally accepted means which academic and independent painters both continued to employ. Building upon what he had painstakingly accomplished in the Moscow sketch, he achieved a sense of the atmosphere of the outdoors not through the softening effects of scumbling and glazing but through the opaque application of precisely chosen tones. He succeeded in creating a powerful illusion of solid masses existing within a three-dimensional space not by using a gradually modulated chiaroscuro and continuous modeling but through the judicious use of form-describing contours and the juxtaposition of abruptly faceted planes of color. At the same time, he undertook to effect a rapprochement between three-dimensional illusionism and the material reality of the painted surface. He emphasized the surface by strengthening the outlines of his figures and objects and insisting upon their nature as painted lines as well as tools for the description of forms; he applied his pigments flatly and thickly and over sufficiently broad areas for them to retain their physical quality as paint and their identification with the plane of the canvas upon which they were placed. He accomplished a work which, at one and the same time, gave new vitality to the age-old concept of the picture as an illusion of the world out there and stated boldly and dramatically his newly attained conception of the canvas as a field for artifice, as the realm where vision and invention may meet and a synthetic union be effected.

In the latter respect, Monet was linked to the most advanced painting of his time. During the fall of 1865 and the winter of 1866, as he worked on his *Déjeuner sur l'herbe*, Monet was moving conceptually and stylistically closer to Manet. He began a series of investigations which paralleled Manet's attempts to bring about change and renewal in the art of their time.

By the end of 1862, Manet had produced a series of paintings which, despite and through their complex relationship to the art of

the old masters, inaugurated an important revaluation of the traditional means of achieving pictorial form. Building upon the example of Courbet, e.g., the *Burial at Ornans*, and his new awareness of the oil paintings of Goya, he injected pure, somewhat crudely applied colors into the otherwise conventionally toned environments of the *Musique aux Tuileries* [15] and *Lola de Valence* (Louvre). In these and other paintings of 1862–3, including the *Déjeuner sur l'herbe* [14] and *Olympia*, he emphasized the poles of the value scale in his treatment of figures by reducing the role of mediating tones; in so doing he reduced the assertion of physical mass as his shadows became boundaries, his modeling circumscription. Space was compressed as in the *Olympia* or denied its rational diminution as in the *Mlle Victorine in the Costume of an Espada*, where he chose to emphasize the linking of directions and the juxtaposition of forms upon the surface in relative disregard of the traditional concern with three-dimensional coherence.[90] In a series of seascapes of 1864, most notably *The Battle of the Kearsarge and the Alabama* [42], he manipulated the shapes of boats against the decoratively conceived plane of the sea and in relation to the rectangle of the frame so as further to establish his sense of the organization of the picture plane as a primary formal concern for painting.[91]

Manet's art was born largely from different sources than was Monet's. He sought more deliberately in the work of the old masters or in such graphic media as the newly introduced Ukiyo-e prints from Japan the models for his art. Monet, though not indifferent to such sources, was less committed to them; his primary point of departure was nature. Whereas Manet conducted his experiments by excavating in the archives of past art, Monet proceeded, in his next major painting, to dig a trench in his garden so that he might handle the large canvas of the *Femmes au jardin* entirely outdoors.[92] Yet, although they may have found their main stimuli in seemingly opposed areas, the work of both painters evidences similar concerns. Manet led the way. But it must be said that no other artist seemed to realize as fully as did Monet the formal

42. *The Battle of the Kearsarge and the Alabama*, Edouard Manet, 1864

meaning of Manet's paintings. Monet's heightened colors in his *Déjeuner sur l'herbe* are the equivalent of Manet's restricted gray harmonies; his broadly contoured figures are the direct counterpart of Manet's more finely silhouetted ones; his semi-abstract clarification of seemingly immaterial highlights and flickers helps to build up a surface consistency which reveals him as sharing Manet's concern for the two-dimensional identity of the canvas upon which he worked. Monet's *Femmes au jardin*, to which he next turned, establishes still more clearly the close coincidence of effort between the two artists and in so doing helps to clarify the position of the *Déjeuner sur l'herbe* within Monet's early career.

43. *Le Fifre*, Edouard Manet, 1866

In April of 1866, Monet moved to Sèvres, near Ville-d'Avray, just outside of Paris; there he attempted to continue and develop the style which he had begun to forge during the year's work on the *Déjeuner sur l'herbe*. Unlike the *Déjeuner*, however, which was ultimately a product of the studio, the *Femmes au jardin* [45] was to be executed entirely in the open air. He was still interested in projecting his vision on a large scale but restricted himself to more manageable dimensions (approximately 8×7 feet) to ensure that his goal be met.[93] Nevertheless, the painting suggests, in its strict coordination of design, that Monet's observation of natural effects was to be integrated into a pre-established formal scheme. In the *Déjeuner*, Monet had attempted to reconcile a firm decorative organization with the powerful illusion of three-dimensional bodies existing in space, and the inherent difficulties aggravated by the large scale may be seen as the primary reason for his failure to bring the work to completion.[94] In the *Femmes au jardin* the conflict was resolved in favor of the surface. The *Femmes* may thus be seen as a logical solution to the problems which the *Déjeuner* had presented. It poses, as well, a solution to one of the most pressing concerns of painting at the time. The 1860s mark a particularly crucial stage in the history of the passage from the past to the present. Throughout the decade, critical attention was paid to the disparity between traditional procedures and the need to establish a modern style of painting.[95] One approach which artists took was to combat the authority of illusionism as unquestioned guide and standard. The year 1866 stands out as an important moment in which these concerns were stated and an alternative offered. Monet's organization of the *Femmes au jardin* is related to efforts made at that time by both Manet and Degas.

During May and June of that year, Manet held a private exhibition at his studio on the rue Guyot; there he exhibited his *Fifre*, which had just been rejected by the Salon, and several other paintings. The *Fifre* [43] offered a more thoroughgoing example of decorative principles than any work which Manet had created up

to that time. It is a painting almost without shadow, little modeling, and with few clues to enable a reading in depth. The figure and surrounding air are as interlocking shapes, fitted into the surface like pieces in a simplified jigsaw puzzle. Other works shown in the rue Guyot underlined the formal message of the *Fifre*: the *Femme au perroquet* (Metropolitan Museum), so strikingly at variance with Courbet's painting of the same subject triumphantly appearing at the Salon, emphasizes the broad shape of the woman's pink costume.[96] Several bullfight paintings, particularly the *Combat de taureaux* now in the Art Institute of Chicago, display a deliberate arrangement of flattened shapes against the horizontally and vertically organized planes of the bullfighting arena.

The formal message of Manet's paintings was furthered by a remarkable canvas by Degas on view at the Salon - *Steeplechase - The Fallen Jockey* - which concentrates upon the large shapes of horses sweeping across the canvas [44]. Despite the large size of the painting - approximately six by five feet - the horses and jockeys are outlined in fine running strokes which deftly deny the necessity for traditional modeling. The palette is composed of delicate, warm shades, with shadow tones reduced to a minimum. The composition is conceived largely in terms of the surface: the shapes of the horses seem pinned to the plane of the turf, which extends vertically almost to the top of the canvas. The decorative principle is so thorough as to make the firmly, conventionally modelled head of the fallen jockey seem a bizarre and alien element within the painting.[97]

Monet must certainly have scrutinized Degas's painting at the Salon, and he may well have had the opportunity to study Manet's paintings at the rue Guyot studio.[98] The *Fifre*, in particular, would have struck him by reason of its clarity. He could have compared it to his Salon painting *Camille* [12], which was also a single-figure composition, and to the figures in his *Déjeuner sur l'herbe*. But whether this proposed visit actually occurred or not, Monet's *Femmes au jardin* [45] was developed in a manner consistent with Manet's new paintings and with Degas's Salon canvas. In the

44. *Steeplechase - The Fallen Jockey*
Edgar Degas, 186

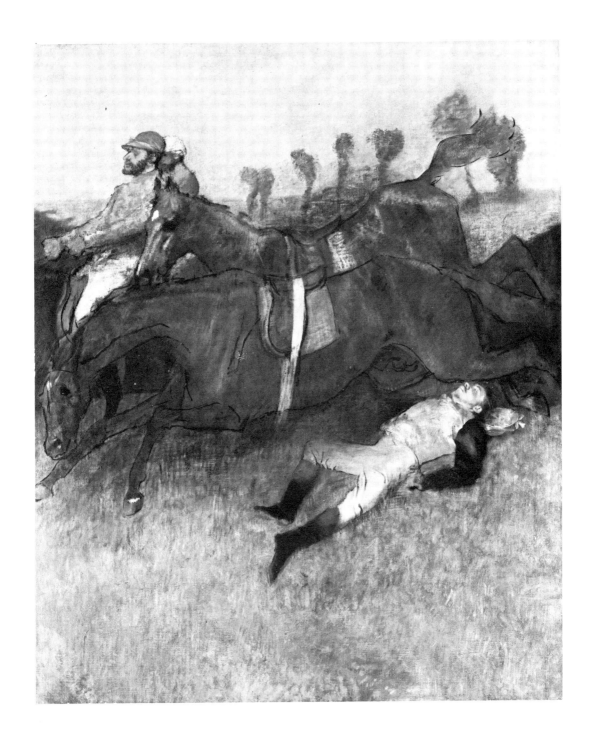

Femmes, conceived in a spirit of fidelity to appearances, the decorative principle seems to have been posited from the first. Despite, or along with, the establishment of a convincing suggestion of spatial recession,[99] Monet coordinated all the means he could command – line, color, texture, the disposition of parts and the arrangement of the whole – to emphasize the surface of the canvas as a palpable entity. The cylindrically formed bodies which played such an important role in the spatial expression of the *Déjeuner* are here transformed into flat silhouettes in simple frontal or profile poses; they function more as shape than as mass. Within the dresses of the women, close-valued hues – inevitably more modified in their space-creating effect than the value contrasts associated with traditional chiaroscuro – are employed; they serve to affirm or, at the very least, not destroy, the two-dimensional nature of the canvas.

Within the figures a single stroke of the brush will link two spatially disparate forms on the same plane.[100] Twigs and leaves join with the figured dresses of the seated woman and the flower gatherer at the right, producing a calligraphic interplay which unites the figures with the setting. The rendering of the selective fall of light upon the scene serves the same end: light and shadow pass across the foreground figure, ignoring volume, joining figure and ground according to their situation in light or in shade. An equivalence between figure and ground is established which serves to cancel spatial readings, locking both, at least momentarily, into the same plane as part of an overall pattern. The *Femmes au jardin* is a highly unified painting in which the definition of mass is adjusted to the depicted action of the immaterial, the independent play of light is combined with a flattened, simplified rendering of form, and the application of pigment is uniform throughout. Light, shadow and substance are treated as one, geared to the creation of a phenomenal and decorative unity.

Manet's and Degas's latest paintings and Monet's long months of work on the final canvas of the *Déjeuner sur l'herbe* led in the same direction. The *Femmes au jardin* is, in the last analysis, no less

45. *Femmes au jardin*, Claude Monet, 1866–7

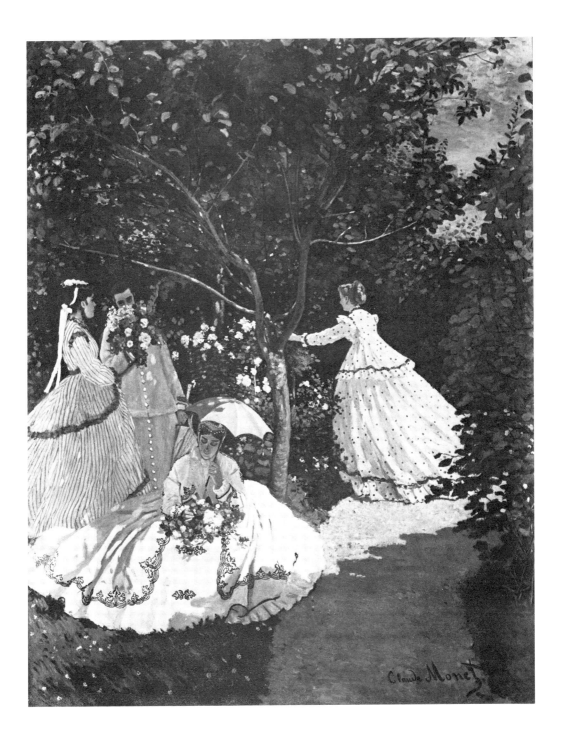

artificial than the *Déjeuner*, but it achieves a greater formal homo-geneity. It joins with Manet's paintings, in particular, to mark a major stage in the history of nineteenth-century painting. Together they state the case against illusionism as an artistic goal and for the canvas as protagonist in the painting of the mid-1860s. They reveal, in relation to later examples of advanced painting, such as Gauguin's *Vision after the Sermon* or Seurat's *Le Cirque*, that the clear silhouette, the flattened mass, the outspoken contour, the crystal-lization of color areas, the collapsing of space, stand at the beginning as well as at the end of Impressionism.

The *Femmes au jardin*, in turn, serves to stamp the *Déjeuner sur l'herbe* as a work hanging on the brink. In the final version of the *Déjeuner* many of the formal characteristics of the *Femmes* are to be found: the uniformity of pigment texture, the beginnings of a system of closely related hues of similar value (established mainly through the introduction of delicately tinted shadows), clearly circumscribed figures, and the abstract network of light. All aid in the creation of surface unity. But in the *Déjeuner* these devices are in conflict with the powerful definition of massive forms in space, effected by the faceted modeling, precise contouring, and secure positioning of figures within the setting. The *Déjeuner*, envisioned, in its scale and contemporaneity of theme, as a logical culmination of the traditional, and essentially realistic, conception of the canvas as a window upon the world, was, in form, caught between the old and the new, between the expression of the imitative function and the recognition of the artificial quality of the painter's enterprise. The evolution from the *Déjeuner* to the *Femmes au jardin* suggests that only when he reached monumental size did Monet become fully aware of the arbitrary character of his means - color and line upon a flat surface. At the moment that he approached mastery of illusion he felt compelled to recognize and assert the nature of his tools and the identity of the canvas upon which he worked. The *Femmes au jardin* is not devoid of discord - the precise observation

of natural effects is somewhat at variance with the controlled decorative organization of the canvas. But harmony is achieved in terms of two-dimensional integration. By contrast, it serves to mark the *Déjeuner* as a transitional work, seeking to serve, in a bold and extravagant fashion, both the claims of illusionism and those of the picture plane. The attempt to adjust these claims is seen in almost every detail of the painting. Expanded to the entire canvas, this effort serves to point up the elements of tradition and innovation which, in their problematic relationship, are at the heart of the *Déjeuner*. As Manet's canvas upon which it was based, Monet's *Déjeuner sur l'herbe* states, fragmentary and silent though it was in the nineteenth century, the position of advanced painting in the mid-1860s, suspended still between the past and the present.

Appendix:
Two Letters from Monet to Amand Gautier

Below are presented the complete texts of two unpublished letters from Monet to his friend the painter Amand Gautier. Written in April and May 1866, they help to shed some light on Monet's activities at the time when he abandoned the *Déjeuner sur l'herbe* in Paris and moved hastily to Ville-d'Avray to escape the claims of his creditors. The first letter emphasizes his precarious financial situation (see pp. 28, 30 above); the second refers to his successful exhibition of *Camille* at the 1866 Salon and clearly reveals the rise in a young painter's fortunes that attends acceptance at the Salon coupled with a modicum of critical approval. As a result Monet was able to sell a number of paintings and be assured of the continued assistance of his aunt, Mme Sophie Lecadre, whose earlier support of his career had been wavering (see n. 35 below).

Gautier had earned the respect and friendship of Mme Lecadre and was in a unique position to act as intermediary, on Monet's behalf, between her and his friend. The letters indicate his effectiveness in this role. Gautier's task was made easier with the success of *Camille*. He immediately wrote to Mme Lecadre, complimenting her on her nephew's accomplishment and enclosing a copy of Emile Zola's laudatory review in *L'Evénement* (she received at least three other copies from other sources, as well). Seeing that Monet had now begun to make his mark within the official art world, she ceased to waver and agreed to provide him with a steady, if limited, allowance.

The second letter also indicates the generally favorable circumstances in which Monet found himself as he was about to begin the *Femmes au jardin* at Ville-d'Avray. His financial cares temporarily

allayed, he expresses his satisfaction with his country surroundings and finds renewed energy with which to return to his art.

The two letters are in the collection of the Bibliothèque d'art et d'archéologie, Paris. They are presented here with the original spelling and punctuation observed.

Letter I: Monet to Amand Gautier, manuscript, signed, neither place nor date indicated, 3 pp. in 8°; Bibliothèque d'art et d'archéologie, carton 22 peintres, aut. 26.

[Sèvres, end April 1866][101]

Mon cher Gauthier [sic]

Je suis enfin déménagé. je suis venu me retirer dans une petite maisonnette près de Ville-d'avray. j'ai pris décidément un grand parti, celui de laisser de coté *pour le moment* toutes mes grandes choses en train qui ne feraient que me manger de l'argent et me mettaient dans l'embarras.[102] J'ai fait part de tous cela à ma tante qui en paraît très satisfaite, vous ne saurez croire combien elle est reconnaissante de l'interêt que vous me portez du reste de mon coté vous n'aurez jamais à me reprocher l'ingratitude, sans vous, – encore cette fois-ci je pouvais me trouver dans un grand embarras, vous avez écrit une lettre qui a de suite fait changer les intentions que l'on avait pour moi, je vous en remercie de tout mon coeur, vous n'aurez pas à vous en repentir.

Je n'ai pu assister à votre mariage car juste à ce moment [je] déménageais j'espère bien que vous ne m'en voudrez pas car il n'y avait de ma faute. je ne sais si ma lettre vous trouvera à Paris, de toutes les façons elle vous arrivera toujours et je viens encore vous demander un service, j'ai bien besoin d'argent je voudrais vendre quelque choses car il me faut une certaine somme pour le 1^e mai, je ne vous demande pas de me faire acheter quelque chose je sais que ce n'est guère possible je voudrais seulement que vous recommandiez à Détrimont s'il voulait bien se charger de me prendre quelques tableaux chez lui afin que j'ai un endroit où je puisse

envoyer des personnes voir ce que je désire vendre car en ce moment j'ai plusieurs choses terminer et naturellement on ne viendra pas me les chercher à Ville d'avray. vous seriez bien aimable de m'écrire à ce sujet et si cela vous est possible donnez-moi donc quelques renseignements pour l'exposition de Lille voici mon adresse chemin des closeaux à Sèvres, près la station de ville d'avray, seine et oise en attendant votre réponse croyiez moi bien votre reconnaissant et fidele ami.

Claude Monet

Letter II: Monet to Amand Gautier, manuscript, signed, Sèvres, 22nd May 1866, 2 pp. in 8°; Bibliothèque d'art et d'archéologie, carton 22 peintres, aut. 27.

Sèvres ce mardi 22 mai 1866

Mon cher Gauthier [sic]

Je viens vous remercier de votre bontée, de l'interêt que vous me porter, j'ai reçu ces jours passés une lettre de ma tante qui me dit avoir reçu de vos nouvelles datés de Lille, vous lui faites compliments de mon succes au salon, merci de tout mon coeur.

Ma tante paraît enchanté de tous les cotés elle reçoit des felicitations elle n'a reçu que de trois personnes l'évènement que vous avez envoyé aussi[103] Ma tante me dit que vous devez être à Paris maintenant au premier jour je dois venir à Paris, ma première course sera pour venir vous voir ce sera probablement jeudi.

Je suis de plus en plus heureux d'avoir pris le parti de me retirer à la campagne je travaille beaucoup avec plus de courage que jamais. Mon succès du salon m'a fait vendre plusieurs toiles depuis que vous êtes absent j'ai fait 800 fr. J'espère que quand je serais en relation avec plus de marchand cela ira mieux encore.[104]

en hate je vous serre cordialement la main. à bientot.

Claude Monet
Chemin des closeaux à Sèvres

Notes

1. 'Une nouvelle manière en peinture: Edouard Manet', in Emile Zola, *Salons*, ed. F. W. J. Hemmings and R. J. Niess, Paris: Minard; Geneva: E. Droz, 1959, p. 96. First published in the *Revue du XIXe siècle*, 1, January 1867.

2. Until recently it was believed that it was in 1866 that Monet was forced to leave his canvas with his landlord, either in Paris or Chailly, as security for non-payment of rent, and it has been suggested that that was the reason for its incompletion. We now know that Monet kept the canvas with him, probably rolled up but intact, until January 1878, when he left it with his landlord, Alexandre Flament, at Argenteuil. It was still with Flament in 1884, at which time Monet entered into negotiation with him to retrieve it. On 11 March 1884, Monet wrote to his dealer, Durand-Ruel: 'Je suis en correspondance avec un ancien propriétaire d'Argenteuil qui avait gardé une énorme toile de moi en payement . . . c'est une toile de 6 mètres, très médiocre mais que je serais très heureux de revoir.' Lionello Venturi, *Les Archives de l'impressionnisme*, Paris, New York: Durand-Ruel, 1939, I, p. 274, letter 92. Oscar Reuterswürd, *Monet*, Stockholm: Albert Bonniers, 1948, p. 157, was the first to note this but without supporting documentation. Charles M. Mount, *Monet*, New York: Simon & Schuster, 1966, pp. 276, 419, cited the letter to Durand-Ruel, and Rodolphe Walter, 'Les Maisons de Claude Monet à Argenteuil,' *Gazette des Beaux-Arts*, 6th series, LXVIII, December 1966, pp. 338–9, presented another letter to Alice Hoschedé, in which essentially the same information as in the Durand-Ruel letter is provided. Walter did not identify the *Déjeuner* in his article but has confirmed that it was that painting in a letter to the author dated 24 July 1970. It is more likely, however, that Monet utilized the canvas in this way only once, in 1878. The story seems to have been told quite clearly by Monet to René Gimpel in 1920: '. . . la toile est restée roulée des années chez un bonhomme qui l'avait engagée; elle était même beaucoup plus grande, et quand elle me fut rendue j'ai dû la couper.' Gimpel, *Journal d'un collectionneur*, Paris: Calmann-Lévy, 1963, p. 179.

3. Duc de Trévise, 'Le Pèlerinage à Giverny', *La Revue de l'art ancien et moderne*, LI, February 1927, p. 121. On another occasion Monet called it a *Déjeuner dans la forêt*; Marc Elder, *Chez Claude Monet à Giverny*, Paris: Bernheim-jeune, 1924, p. 27. For color reproductions of the central section, see William Seitz, *Claude Monet*, New York: Abrams, 1960, p. 67, and Jean Leymarie, *French Painting, the Nineteenth Century*, Geneva: Skira, 1962, p. 176.

4. G. Bazin, *Impressionist Paintings in the Louvre*, trans. S. Cunliffe-Owen, 2nd ed., London, 1959, p. 20.

5. Zola used this phrase to characterize Manet's paintings in the title of his extensive 1867 article on Manet. See n. 1.

6. Survey of literature on the *Déjeuner sur l'herbe*: The early literature on Monet contains only a few passing references to the project. The basic biography on Monet is Gustave Geffroy, *Claude Monet, sa vie, son oeuvre*, Paris: Crès, 1922 (since the two-volume edition of Geffroy's book will be cited here [Paris: Crès, 1924], chapter numbers will be given to facilitate reference). Geffroy's account was based, presumably, on conversations with the artist during their long years of friendship, which dated back to 1886, but his discussion is extremely sparse (I, ch. 6, pp. 37–40). Following a brief appreciation of the originality and beauty of Monet's conception and execution, coupled with a recognition of Manet's role in stimulating the enterprise, Geffroy presents a description of the central fragment, which he had had an opportunity to examine on many occasions in Monet's studio. According to Geffroy, Monet abandoned the canvas as a result of dissatisfaction with revisions he had made in accordance with the advice of Courbet. A still more brief discussion, based upon a 1920 interview with Monet, was published by the Duc de Trévise in 1927 (*La Revue de l'art ancien et moderne*, pp. 121–2). Monet told Trévise that the painting was undertaken with Manet's *Déjeuner sur l'herbe* in mind, and he described succinctly his method of approach: 'I proceeded as did everyone at that time by making small studies from nature, and I composed the ensemble in my studio.' In both accounts, we are told that the canvas was left with his landlord, rolled up, and eventually damaged by moisture. In addition to these sources, both dating from the 1920s, there are occasional references, in letters by Monet, Frédéric Bazille and Boudin, to the painting at the time of its execution. In 1927, the year after Monet's death, Raymond Régamey published an important stylistic study of the early work, including a stimulating comparison of Monet's and Manet's

versions of the *Déjeuner sur l'herbe* ('La Formation de Claude Monet', *Gazette des Beaux-Arts*, 5th period, XV, February 1927, pp. 76–8). Régamey's analysis of Monet's *Déjeuner* was based on the central fragment of the final painting, which was in Monet's possession until the time of his death.

As a result of the Wildenstein donation to the Louvre and the occasional exhibition since the Second World War of the central section, new critical attention has been focused upon the *Déjeuner* in recent years. Hélène Adhémar and Germain Bazin have made notable contributions to its recognition as a major monument of nineteenth-century art: Adhémar, 'Un don au Musée du Louvre. La Partie gauche du *Déjeuner sur l'herbe* de Monet', *Arts* [Paris], no. 633, 28 August–3 September 1957, p. 12; Bazin, *Impressionist Paintings in the Louvre*, pp. 13–20, 23–4, 98, and 'Un chef-d'oeuvre de Monet entre au Louvre', *Figaro littéraire*, 20 July 1957. Mme Adhémar has published a study of the left-hand fragment based upon X-ray examination conducted by the Louvre laboratory, X-ray photographs having yielded information about the stages of execution of the final canvas, which offers material for new insights into Monet's procedure and final intentions: 'Modifications apportées par Monet à son Déjeuner sur l'herbe de 1865 à 1866', *Bulletin du laboratoire du Musée du Louvre*, no. 3, June 1958, pp. 37–41. Gabriel Sarraute's studies on Frédéric Bazille have led to the discovery of two drawings related to the project and the publication of pertinent letters by Bazille and Monet: 'Contribution à l'étude du Déjeuner sur l'herbe de Monet', *Bulletin du laboratoire du Musée du Louvre*, no. 3, June 1958, pp. 46–51, and 'Deux dessins inédits de Claude Monet', *La Revue du Louvre*, XII, 1962, pp. 91–2. See also: Claude Roger-Marx, 'Claude Monet ou les caprices de la gloire', *Figaro littéraire*, 15 October 1957; Seitz, *Claude Monet*, p. 66; Mount, *Monet*, pp. 87–116, 402–4; Kermit Champa, 'The Genesis of Impressionism', unpub. Ph.D. diss., Harvard University, 1964, pp. 266–300; and I. Sapego, *Claude Monet*, trans. V. Friedman and I. Oshurkova, Leningrad: Aurora, 1969, pp. 11–12, and commentary on plate 1, by E. Gyeorgiyevskaya, with additional bibliography. Both Mount and Champa have attempted reconstructions of the process of creation of the *Déjeuner*, based on a rereading of much of the available material. Champa's presentation is of the utmost importance, and many of the views offered here, although independently arrived at, have proved to be in agreement with those developed in his

study. On the other hand, I have numerous serious disagreements with Mount's more detailed presentation; his interpretation of documents, events, sequences, and motives should be scrutinized with the greatest care.

For further information on the history of the *Déjeuner sur l'herbe*, which might serve to alter in details the presentation given here, one awaits the publication of Daniel Wildenstein's *catalogue raisonné* of Monet's oeuvre and the results of Sarraute's studies on Bazille.

7. *Place aux jeunes! Causeries critiques sur le Salon de 1865*, Paris: F. Cournol, 1865, p. 190.

8. *L'Autographe au Salon de 1865*, no. 9, 24 June 1865, p. 76.

9. 'Salon de 1865', *Gazette des Beaux-Arts*, 1st series, XIX, July 1865, p. 26.

10. The painters of the Channel coast have frequently been singled out as forming a distinguishable group during the period from *c.* 1850 to *c.* 1870. They have been referred to as the École de Saint-Siméon, the School of Honfleur, the Barbizon of the North, the Barbizon of Normandy. Saint-Siméon is the name of the farm, situated on the cliffs above the harbor of Honfleur, which served as hostel and meeting place for painters, e.g., Courbet, Daubigny, Diaz, Dupré, Harpignies, Paul Huet and Troyon; among its most important habitués during the late fifties and early sixties were Boudin, Jongkind, and Monet. Maurice Raynal has referred to it as the true cradle of Impressionism; *History of Modern Painting from Baudelaire to Bonnard*, trans. Stuart Gilbert, Geneva: Skira, 1949, p. 5. For an introduction to this school, see Georges Jean-Aubry, *Eugène Boudin*, Paris: Bernheim-jeune, 1922, pp. 42ff; Gustave Cahen, *Eugène Boudin, sa vie et son oeuvre*, Paris: Floury, 1900, pp. 62ff; and the catalogue *Exposition Honfleur et ses peintres*, Musée Municipal, Honfleur, 12 July-9 September 1934.

11. Gaston Poulain, *Bazille et ses amis*, Paris: La Renaissance du Livre, 1932, p. 50.

12. Sarraute, *Bulletin du laboratoire de Musée du Louvre*, p. 50, letter I.

13. ibid., p. 51, letter IV and n. 1. The two panels are catalogued in François Daulte, *Frédéric Bazille et son temps*, Geneva: Cailler, 1952, nos. 15/1, *Marine*, and 15/2, *Saint-Sauveur*. Bazille had great difficulty in fulfilling the commission; he had worked on the paintings throughout the spring and summer, completing them only in August, whereupon he finally joined Monet in Chailly. Bazille's lack of certitude in coping with the project is pointed up by his dependence upon a Monet composition

for developing one of the two paintings (Daulte 15/1), a seascape of the beach and sea near Le Havre. Both the Monet and Bazille paintings are reproduced in John Rewald, *The History of Impressionism*, rev. and enl. ed., New York: Museum of Modern Art, 1961, p. 110, where they are dated 1865. Monet's painting stems from his Normandy campaign of 1864, although it may have been completed in the following year. Bazille's painting was executed only in 1865 to fulfill the above-mentioned commission. Rewald's title, *Seashore near Honfleur*, for Bazille's painting is incorrect; the site is the beach at Sainte-Adresse with the coastline of Le Havre in the distance.

14. Another painting of similar composition, *La Route dans la forêt*, is dated 1864; it appears to represent the Bas-Bréau road and suggests Monet's involvement with the site at least a year before he began work on the *Déjeuner* (repro. John Rewald, *The History of Impressionism*, New York: Museum of Modern Art, 1955, p. 89).

15. Monet's landscape was listed as no. 1387, *Forêt de Fontainebleau*, in the Salon catalogue. It has never been securely identified, but it is undoubtedly *La Route de Chailly à Fontainebleau* [8]. This identification is all but confirmed by a previously overlooked caricature drawing of Monet's Salon landscape by Félix Y [Régamey], 'Le Salon de cette année. – VI. Les paysages', *La Vie parisienne*, IV, 2 June 1866, p. 305. The caption reads: 'Route en forêt: Sévère (sans l'être . . . vert), mais juste.' The drawing [46] shows a road through the trees with a cart in the center of the road. *La Route de Chailly à Fontainebleau* includes two men and a cart trailing a load of logs, pulled by two horses (in Monet's two other extant paintings of the same setting [7, 19] the road is unoccupied). Differences in detail and placement between the caricature and the painting may be explained, e.g., by the minute size of the former and the caricaturist's desire to make the dark cart visible against the light strip of the road. The canvas is large enough to have made it a suitable Salon entry and to have caught the eye of the caricaturist as well as the attention of the critic Thoré, who commented on it favorably in his 1866 Salon; Théophile Thoré, *Salons de W. Bürger, 1861 à 1868*, Paris: Renouard, 1870, II, p. 325.

16. A fourth landscape, *Le Pavé de Chailly*, 97 x 130 cm. (Metropolitan Museum, New York), is more problematical in its relationship to Monet's project. In composition – the closed forest interior and large tree at right – it resembles the final setting for the *Déjeuner*, but the site is clearly not the same, and aspects of the painting's facture, particularly the fleetingly,

46. Caricature by Félix Y, *La Vie parisienne*, 2 June 1866

somewhat dryly brushed strokes of coppery color which describe the underbrush and an overall sense of meticulousness, are not characteristic of the *Déjeuner* and its associated studies.

17. The principal sources of information on Camille are Mount, *Monet, passim* (see index pp. 437–8), and idem, 'New Materials on Claude Monet: the Discovery of a Heroine', *Art Quarterly*, XXV, Winter 1962, pp. 313–28. Mount's documentation is extremely helpful, but his interpretation of the relationship between Monet and Camille is open to serious question.

18. For the charcoal sketch see Sarraute, *Bulletin du laboratoire du Musée du Louvre*, pp. 46–8. The drawing, then in the collection of Richard S. Davis, was shown at the exhibition *Claude Monet*, City Art Museum of St Louis and The Minneapolis Institute of Arts, 1957; it was published for the first time in the exhibition catalogue, no. 98. In the more advanced sketchbook page, which I recently discovered at the Musée Marmottan, three figures, an oddly caricatural man and two women, stand at the left, the seated man at the left edge of the picnic cloth has been established in position, and other figures have been brought a bit closer to the final arrangement of the Moscow sketch. The perspective of the Bas-Bréau road seems at this stage to have been eliminated. The style of the drawing is the same as that of the charcoal sketch. I would like to thank M. Claude Richebé of the Musée Marmottan and M. Emmanuel Bondeville of the Institut de France for permission to mention the Marmottan drawing.

19. Formerly half of a larger sheet containing another drawing; see Sarraute, *La Revue du Louvre*, pp. 91–2. First published in exhibition catalogue *Claude Monet*, City Art Museum of St Louis, 1957, no. 99.

20. Sarraute, *Bulletin du laboratoire du Musée du Louvre*, p. 50. Sarraute indicates this letter was not dated; Mount, *Monet*, p. 90, incorrectly dates it 4 May. He concludes from the words offered here in parentheses ('vous ne m'avez pas répondu si mes tableaux avaient été prêts en temps pour être expédiés je voudrais aussi savoir si mes billets sont payés') that Monet had left his intended Salon canvases with Bazille to be delivered to the jury along with an entrance fee. Since Salon entries were due about 18 March, probably before Monet left for Chailly, and the Salon itself opened on 1 May, these conclusions are unacceptable. Moreover, I have come across no indication that a fee was charged for Salon submissions. It is more likely that the passage refers to the handling of Monet's paintings following the close of the Salon on 20 June or to a separate transaction altogether.

21. Sarraute, ibid., p. 50.

22. The exact date of Bazille's arrival at Chailly is somewhat uncertain. In a letter from Paris to his mother, Bazille notified her that he intended to finish his uncle's paintings the next day and leave immediately for Chailly, where he would stay at the Auberge du Lion d'Or. Daulte, p. 47, dates this letter to 18 August, but Daulte's dates are not always reliable. Sarraute, *Bulletin du laboratoire du Musée du Louvre*, p. 51, letter IV, reproduces a portion of the letter with no date. He reports, n. 2, that after receipt of the letter at Méric, the family's summer home, Bazille's brother Marc wrote down the Chailly address in a notebook, along with the date 28 August 1865. 28 August was a Monday; Bazille's letter was written on a Friday. The date would have to be 18 August, just after Monet's last communication from Chailly on the 16th, or the following Friday, 25 August (mail service was sufficiently rapid to allow for this latter possibility). Bazille joined Monet on Saturday, 19 or 26 August. The Saturday is confirmed by another letter written the following Thursday evening (24 or 31 August; Daulte, p. 48, n. 1, says 23 August), in which Bazille says that he has been at Chailly 'depuis samedi dernier'. Sarraute, p. 51, letter V. One awaits Sarraute's publication of Bazille's letters for a reliable guide to sequence and dating.

23. Sarraute, ibid., p. 51, letter V.

24. Poulain, pp. 56-7; Daulte, no. 14. Musée du Jeu de Paume, Louvre.

25. The paintings executed by Bazille are: *Lisière de forêt à Fontainebleau*, Daulte, no. 11; *Paysage à Chailly*, Daulte, no. 12; *Bazille à la palette*, Daulte, no. 10 (now Art Institute of Chicago. See exhibition catalogue *Frédéric Bazille*, Musée Fabre, Montpellier, 13-31 October 1959); and the *Repos sur l'herbe*, Daulte, no. 13.

26. On that date Bazille's height was measured and inscribed on the door of his father's bedroom at Méric; see the exhibition catalogue *Bazille*, Wildenstein, Paris, June-July 1950, unpaginated (following entry 16, n. 2).

27. The painting has been variously titled, e.g., *Les Promeneurs* (Seitz, *Claude Monet*, p. 13), *Portrait of Mme Monet and Bazille* (*French Paintings from the Nineteenth Century from the Collection of Mrs Mellon Bruce*, The California Palace of the Legion of Honor, San Francisco, 15 June-30 July 1961, no. 27). Hereafter referred to principally as the Washington study.

28. Poulain, pp. 58-9.

29. The reconstruction of the series of events presented here and in the preceding paragraph is my own. Rewald, 1961, p. 128, relates that Monet worked in Normandy during the fall of 1865 with Boudin, Courbet and Whistler. Although it has been generally accepted, I have been able to find no documentation for this contention. There are Normandy paintings by Monet, dated 1865, which would seem to warrant the assumption that he indeed was there during the autumn of the year. Two of these works are clearly the product of his 1864 sojourn, however: *Embouchure de la Seine, Honfleur* (private collection, Paris; repro. Rewald, 1961, p. 122) was exhibited at the 1865 Salon; *La Pointe de la Hève à marée basse* [6] was almost certainly the other painting, listed with that title, to represent Monet at the same Salon (it depicts low tide and is the same size, 91 x 152 cm., as the *Embouchure*). Another dated 1865 seascape, *The Green Wave* (Metropolitan Museum, New York), differs greatly in composition and style from the aforementioned works and is probably a studio product, related more directly to Manet's 1864 marines, e.g., *The Battle of the Kearsarge and the Alabama* [42], than to the experience of the Normandy coast. The reference to Manet's paintings is made also by Mount, *Monet*, p. 77, and Champa, p. 87; both authors cite as well the probable influence of Japanese prints. See also my dissertation, 'The Early Paintings of Claude Monet', University of California, Berkeley, 1967, pp. 81-2. Two factors make it seem highly unlikely that Monet made his yearly trip to visit his family and work on the coast in 1865:1) he was just at the point where he was to begin his large canvas of the *Déjeuner sur l'herbe*, the culmination of six months of preparatory effort, in the Paris studio; 2) he could not have made the trip to Normandy until the second half of October, at a season of the year when there was little likelihood that he would be able to enjoy many working days outdoors. Rather, Monet must have remained in Paris, absorption with his new project having overcome any desire to return to the coast, where he had found such fertile conditions for work one year earlier. Monet had traveled a great distance, esthetically speaking, in the course of the year; he was far away, indeed, from the tonal, tasteful evocations of the coastal scene with which he had made his debut at the 1865 Salon. The view that Monet's work on the *Déjeuner* kept him in Paris during the fall is presented also by Champa, p. 271.

30. Both letters quoted in Jean-Aubry, p. 62.

31. Poulain, p. 59. In this letter Bazille also relates that Monet's father had just visited Paris and given Monet 150 francs. One may speculate

that one reason for the visit was that Monet had not returned to Normandy that fall.

32. Poulain, p. 61. Daulte, p. 50, dates this letter 7 February.

33. Daulte, p. 49, dates the eviction to 4 February. Monet's activities after leaving the rue Furstenberg studio are shadowy and can, at this time, be reconstructed only conjecturally. 1 rue Pigalle is Monet's address as given in the 1866 Salon catalogue. Whether he moved there directly or whether it was an apartment or a studio he occupied there we do not know. Mount, p. 119, questions the reliability of the address on what may well be spurious grounds having to do with Monet's attempts to evade his creditors.

34. On the Bas-Bréau landscape see n. 14 above. *Camille* was painted in only four days, according to the critic Théophile Thoré, who praised it in his review of the 1866 Salon; *Salons de W. Bürger*, II, pp. 285-6. Monet's *Déjeuner sur l'herbe* was specifically designed to provide him with an impressive entry at the Salon, his need for success and notoriety conditioned by his financial ills, which had already become chronic. His inability to complete it must have been a serious blow to him; *Camille* was a desperate but stunning, if stylistically conservative, substitute.

35. Unpublished letter, see Appendix p. 92. Gautier's role as mediator between Monet and his aunt and sometime protectress, Sophie Lecadre, helped to ease Monet's path considerably. A letter from Mme Lecadre to Gautier, thanking him for his interest in her nephew, tells something of the circumstances attending Monet's move to Ville-d'Avray: 'Il est traqué, dépisté par quelques créanciers qui ont pris ombrage de ce qu'il a quitté Paris pour se retirer à Ville-d'Avray.' Marthe de Fels, *La Vie de Claude Monet*, Paris: Gallimard, 1929, p. 96.

36. E.g., passages of the central and left-hand fragments were left in an unfinished state up to the time that the painting was cut up; see pp. 66-9 above.

37. The date 1866 has raised the question whether the Moscow painting is indeed a preliminary sketch or a replica of the large canvas. See Sapego, *Claude Monet*, commentary to pl. 1 by E. Gyeorgiyevskaya, and Denis Rouart, 'Apropos des oeuvres datées de Claude Monet', *Bulletin du laboratoire du Musée du Louvre*, no. 4, September 1959, pp. 62-3. There can be no doubt that it is essentially a sketch, done before the large canvas and designed to serve as its model. For the Moscow painting represents an earlier stage in Monet's conception. The figures are more loosely scattered than in the definitive canvas, where, as the Jeu de Paume

fragment demonstrates, Monet was concerned with tailoring the loose ends of the women's skirts and establishing a more firm position in depth for his figures. Furthermore, the costume changes introduced into the large canvas are in the direction of a more up-to-date style (see pp. 44–5 above). It is difficult to believe that Monet would have returned to an earlier conception of composition and spatial structure and to the older costumes in making a six-foot-wide replica of his great *machine manquée*. It is possible, however, that he might have returned to the sketch to finish it once he had to forgo the larger project. In addition, until recently it was thought that the final canvas was ruined in 1866 (see n. 2 above); since that was not the case, there is less ground for considering the need or desire on Monet's part to have produced a replica.

38. Geffroy, I, ch. 6, p. 40. Geffroy states that at this time Monet left the discarded canvas with his landlord as security for non-payment of rent; he locates the event in the Fontainebleau area, presumably in Chailly. There is no documentary evidence to indicate that Monet returned to Chailly with the *Déjeuner* after leaving there in October 1865 to begin the large canvas in Paris. Monet's letter of end April 1866 (see Appendix, letter I) and that of Mme Lecadre to Gautier (see n. 35 above) indicate that he worked on the *Déjeuner* in Paris - and not in Chailly - up to the time he moved to Sèvres in April.

39. Poulain, p. 62.

40. Trévise, p. 122.

41. It is impossible, given presently available information, to chart Monet's relations with Courbet during this period. Courbet may have visited Monet and Bazille and seen them at work on their Salon paintings any time between 20 November 1865, when he returned from Normandy, and March 1866, when paintings were submitted to the jury. The likeliest period would be December 1865 to January 1866, when Monet and Bazille were together at rue Furstenberg, not far from Courbet's rue Hautefeuille studio on the left bank. After 4 February, Monet and Bazille moved from the area to new locations on the right bank. According to Poulain, p. 57, Courbet was in Chailly to witness Monet's work on the *Déjeuner* at an early stage, after Monet's recovery from his leg wound, at which time he is also said to have introduced Monet and Bazille to Corot. There is no clear evidence for this, however. Monet's accident must have occurred during the last week in August at the earliest (see n. 22 above). By 8 September, Courbet was in Trouville; on that date he wrote that he had completed at least four paintings and begun another and had

already achieved a popular reputation there; Gerstle Mack, *Gustave Courbet*, New York, 1951, pp. 202-3. He must have arrived at Trouville by 1 September at the latest, making it all but impossible to credit Poulain's information.

42. See the discussion in my dissertation, pp. 139-43.

43. The resemblance of this figure to Courbet has been stressed by Mme Adhémar, *Bulletin du laboratoire du Musée du Louvre*, pp. 40-41, and noted by Seitz, *Claude Monet*, 1960, p. 66. Geffroy, I, ch. 6, p. 39, identified the figure as Albert Lambron des Piltières, a student of Flandrin and Gleyre and friend of Monet. Geffroy's account is unclear, however, in that he discusses the Moscow sketch and the central fragment of the large·canvas (he knew them both) interchangeably. A close reading indicates that he is speaking of the final canvas in identifying Lambron; his description accords with what we see there [2]: 'Assis sur l'herbe, un autre homme, face réjouie, beau garçon, cheveux bouclés, barbe châtaine en collier . . .' The corresponding figure in the Moscow sketch is clean-shaven. Mme Adhémar considers, perhaps wrongly, that Lambron is the figure in the Moscow sketch. The fact remains, however, that the figure in the Paris fragment strikingly resembles Courbet. The only feature alien to his appearance is the turned-up ends of the mustache, a detail which can be found in no painting, drawing, caricature, or photograph of Courbet of which I am aware. I have been unable to locate a portrait of Lambron which might decide the question.

44. *Pierre-Joseph Proudhon et sa famille* (Petit Palais, Paris) was exhibited at the 1865 Salon. As a result of criticism Courbet afterwards removed the figure of Mme Proudhon, who was seated in an armchair at the right, substituting a background of foliage. He reduced the number of steps from three to two. The painting measures almost 5 feet x $7\frac{1}{2}$ feet; consequently the changes Courbet made amounted to a major undertaking. Monet may have even solicited Courbet's opinion on how to go about making extensive changes on a large canvas, for, as will be discussed further on, he was in the process of making such alterations himself. For a photograph of the first version of the *Proudhon*, see Mack, p. 43.

45. Efforts at forming independent group exhibitions were made or envisioned in the succeeding years but met with no success until the 1874 Impressionist exhibition. See Albert Boime, 'The Salon des Refusés and the Evolution of Modern Art', *Art Quarterly*, XXXII, Winter 1969, pp. 411-26.

46. Cf. the letter from Bazille to his parents, 4 May 1866; Daulte, p. 50, n. 1.

47. Baudelaire, *The Painter of Modern Life and Other Essays*, trans. and ed. Jonathan Mayne, London: Phaidon, 1964, pp. 1, 40.

48. Aaron Scharf, *Art and Photography*, London, 1968; Baltimore, 1969, p. 276. I am indebted to John Fleming for pointing out this reference to me.

49. For a recent discussion of the renewal of interest in the art of the eighteenth century, particularly that of Watteau, see Michael Fried, 'Manet's Sources, Aspects of his Art, 1859–1865', *Artforum*, VII, March 1969, pp. 47-9 and *passim*. The similarity between Monet's *Déjeuner* and van Loo's *Une halte de chasse* has been cited by Sapego, *Claude Monet*, p. 12.

50. For a discussion of the relationship of Watteau's *fêtes* - and Manet's *Déjeuner sur l'herbe* - to the earlier Venetian tradition of mythological paintings associated with the pleasures of the gods, see Fritz Saxl, 'A Humanist Dreamland', in *A Heritage of Images*, a selection of lectures by Fritz Saxl, Harmondsworth: Penguin, 1970, pp. 89-104. Both Werner Hofmann, *The Earthly Paradise*, trans. Brian Battershaw, New York: Braziller, 1961, p. 381, and Beatrice Farwell, 'A Manet Masterpiece Reconsidered', *Apollo*, LXXVIII, July 1963, pp. 45-51, have viewed Manet's *Déjeuner* as presenting the theme of the earthly paradise. Consistent with this interpretation, in regard to Monet's painting, is the prominence of the heart and initials carved into the trunk of the tree at the right. Whether Monet was thinking in such terms or whether he was merely being faithful to the specific data of this 'domesticated' rural setting is a question which should be raised (and I would like to thank John Fleming for doing so) but which I am unable to answer at present.

51. *Arts*, 28 August–3 September 1957, p. 12. Baudelaire's essay appeared originally in three parts in *Le Figaro*, 26 and 28 November, and 3 December 1863. It was actually written several years earlier, between November 1859 and February 1860; Baudelaire, *The Painter of Modern Life and Other Essays*, p. xviii.

52. 'The Salon of 1845', *Art in Paris 1845–1862*, trans. and ed. Jonathan Mayne, London: Phaidon, 1965, pp. 31-2. For a discussion of the movement of ideas associated with the turn to an expression of the contemporary, beginning in the 1830s, see Léon Rosenthal, *Du Romantisme au réalisme*, Paris: Laurens, 1914, pp. 373 ff. Rosenthal, pp. 377 ff., also discusses the differences between the new spirit of the contemporary in art and the continuing tradition, for the most part sentimental and melodramatic, of genre painting in France.

53. On concerns with the nature of the French tradition in art, see Fried, *Artforum*, pp. 41-68 *passim*.

54. 'Philosophie du Salon de 1857', *Salons*, Paris: Charpentier, 1892, I, p. 11.

55. 'Salon de 1863', ibid., pp. 102, 106.

56. The phrase is Baudelaire's: 'The Salon of 1845', *Art in Paris 1845-1862*, p. 32.

57. Here quoted from George H. Hamilton, *Manet and his Critics*, New Haven: Yale University Press, 1954, p. 49.

58. Fom *Du principe de l'art et de sa destination sociale*, Paris: Garnier, 1865, p. 203. Here quoted from Linda Nochlin, ed., *Realism and Tradition in Art 1848-1900*, Englewood Cliffs, New Jersey: Prentice-Hall, 1966, p. 50.

59. 'Le Réalisme et l'esprit français dans l'art', *L'Art et les artistes modernes en France et en Angleterre*, Paris: Didier, 1864, pp. 39-40. Originally published in the *Revue des deux mondes*, XLVI, 1863, pp. 218-37.

60. 'Salon de 1866', *Salons*, I, p. 225.

61. Poulain, pp. 62-4. The accommodation accepted by Bazille between the notion of pure painting and the belief in contemporary subject matter was to characterize advanced painting of the next twenty years.

62. Adolphe Tabarant, *Manet et ses oeuvres*, Paris: Gallimard, 1947, p. 38.

63. *Art in Paris 1845-1862*, pp. 199-200.

64. Thiébault-Sisson, 'Claude Monet: les années d'épreuves', *Le Temps*, 26 November 1900 (an interview with Monet; trans. as 'Claude Monet: The Artist as a Young Man', *Art News Annual*, XXVI, 1957, pp. 127-8, 196-9). There is every likelihood that Monet viewed Manet's work in this way in 1865 as well. In this connection, one may cite a passage in Baudelaire's *Le Peintre de la vie moderne* which seems to castigate Manet's method while stressing direct observation of one's immediate surroundings: 'If a painstaking, scrupulous, but feebly imaginative artist has to paint a courtesan of today and takes his "inspiration" . . . from a courtesan by Titian or Raphael, it is only too likely that he will produce a work which is false, ambiguous, and obscure.' *The Painter of Modern Life and Other Essays*, p. 14. Monet could easily have recognized in these words a reference or connection to Manet and thus received stimulus or encouragement to carry out his modern revision of Manet's *Déjeuner*.

65. *The Painter of Modern Life and Other Essays*, p. 12.

66. ibid., pp. 13–14 and *passim*.

67. H. Adhémar, *Bulletin du laboratoire du Musée du Louvre*, June 1958, pp. 37–41.

68. Baudelaire, *The Painter of Modern Life and Other Essays*, p. 11.

69. ibid., pp. 1–2.

70. My translation. 'Ces gravures peuvent être traduites en beau et en laid; en laid, elles deviennent des caricatures; en beau, des statues antiques.' Baudelaire, *Oeuvres complètes: L'Art romantique*, ed. Jacques Crépet, Paris: Conard, 1925, p. 51.

71. In 1865 at least twenty magazines specializing in the presentation of women's apparel through carefully designed and hand-colored plates were being published in Paris. Beyond this, many journals included less elaborate fashion illustrations in their pages. See Vyvyan Holland, *Hand-Coloured Fashion Plates, 1770–1899*, London, 1955, pp. 97–131.

72. Other graphic sources suggest themselves as well, such as contemporary magazine illustrations of the life and leisure customs of the day, which offered countless examples of outdoor settings filled with people. The final version of the *Déjeuner*, in its use of pure hue and strongly outlined forms, may even betray an interest in the formal aspects of popular prints, e.g., *Images d'Epinal*, as a source for a modern style. Monet's *Femmes au jardin* of 1866–7 [45] also brings to mind the Japanese woodcut as a source upon which Monet may have drawn at this time.

73. A striking comparison, in color and pose, to the two women at the left as they appear in the Moscow sketch may be found in a plate from *Les Modes parisiennes* of 1863 [26], repro. in colour in Max von Boehn, *Die Mode, Menschen und Moden im neunzehnten Jahrhundert*, 5th ed., III, Munich: F. Bruckmann, 1925, facing p. 96. For a further discussion of the relationship between Monet's paintings, esp. the *Femmes au jardin*, and fashion illustration, see Mark Roskill, 'Early Impressionism and the Fashion Print', *Burlington Magazine*, CXII, June 1970, pp. 391–5, and the sections of my dissertation dealing with the *Déjeuner* and the *Femmes*, chs. 5, 6. Roskill has suggested, n. 22, that some of the dresses in the *Déjeuner* may have been rented, basing his suggestion on the fact of Bazille's having rented a green dress for the model for one of his 1866 Salon entries. Camille, however, had only recently joined Monet and was still in the good graces of her reasonably well-to-do family. In later paintings of her in the 1860s and 1870s, she is fashionably dressed and coiffed, and it may be fair to infer that she possessed an ample and

up-to-date wardrobe in 1865. Nor, as the photograph reproduced here
[18] indicates, were these costumes unduly elegant or inappropriate to an
outdoor picnic scene.

74. Douglas Cooper has seen a connection between Camille's pose and
that of the standing woman with a shawl in the right foreground of
Courbet's *The Painter's Studio*, suggesting that Monet based himself on
Courbet's example; Arts Council of Great Britain, *Claude Monet*, The
Tate Gallery, London, 26 September–3 November 1957, no. 7, p. 41. In
view of the common occurrence of this pose in both magazine and fashion
illustration during the 1850s and 1860s, one may equally suggest, despite
the similarity in style, which Cooper also observes, between the Courbet
and Monet, that both artists may have had recourse independently to a
source in popular illustration. See also Roskill, *Burlington*, p. 392.

75. One year earlier, in April 1866, Bazille had written to his parents
of Courbet's popular triumph at the Salon: 'Il expose de fort belles choses
il est vrai, mais bien inférieures à ses *Baigneuses, Demoiselles de la Seine*,
etc.' Daulte, p. 52. In 1867, reporting on Courbet's private exhibition
across from the Exposition Universelle, Monet wrote to Bazille: 'Dieu!
que Courbet nous a sorti de mauvaises choses! Il s'est fait beaucoup de
tort, car il avait assez de belles choses pour ne pas tout mettre.' He went
on to criticize Manet in the same vein, half approving, half disapproving;
Poulain, p. 94.

76. Monet's familiarity with Courbet's *Demoiselles* is rendered all but
certain by Bazille's acknowledged acquaintance with the work in his
April 1866 letter (see preceding note). The canvas remained with
Courbet following its exhibition at the 1857 Salon and was still in his
possession when shown at his independent exhibition of 1867; it could
be seen at his studio during the intervening years. Very few other works
by Courbet suggest themselves as being related to the *Déjeuner*. Courbet's
La Curée (Boston Museum) contains a man leaning against a tree, which
may have inspired the similar figure at the right of Monet's Moscow
version of the *Déjeuner*. *La Curée* was painted in 1857, exhibited at the
Salon of that year, then again in 1860, and on two occasions in 1863. A
somewhat similar figure is found in the Metropolitan Museum's *Après
la chasse* (*c.* 1863).

77. Beyond this there remains Geffroy's account of Courbet's personal
intervention in the later stages of Monet's work on the *Déjeuner* and the
possibility that he actually posed for the seated male figure in the central
section of the final canvas (see pp. 30–31 above and ns. 41, 43).

78. The most frequently accepted date for Monet's first meeting with Manet is 1866, when Astruc is said to have brought the two painters together; Théodore Duret, *Histoire de Edouard Manet et de son oeuvre*, Paris: Bernheim-jeune, 1919, p. 75. Rewald, 1961, p. 172, follows Duret. According to Elder, p. 38, Monet corroborated this story, but in his interview with Thiébault-Sisson in 1900, Monet said that he and Manet did not meet until 1869. Adolphe Tabarant, 'Autour de Manet', *L'Art vivant*, IV, 4 May 1928, p. 344, gives the year as 1867. Bazille's biographers lead one toward an earlier date. According to Daulte, p. 38, Bazille and Manet met as early as fall 1863. Poulain, pp. 48-9, says that both Monet and Bazille met Manet early in 1865 through the Lejosne family. The earlier date has much to recommend it, considering the close ties of both Manet and Bazille to the Lejosne circle.

79. Courbet's painting (Wallraf-Richartz Museum, Cologne) presents a large-scale picnic scene with similarities to Monet's painting in the attitudes of figures and the still life in the foreground. It was painted in Frankfurt in 1858 and appears to have remained in Germany, making it unlikely that Monet ever saw it. Mount, *Monet*, pp. 90, 97, contends that Monet was attempting to emulate Winterhalter in order to achieve a Salon success and that formal aspects of the *Déjeuner* were influenced by Winterhalter's painting.

80. Tissot's *Déjeuner sur l'herbe*, 20.5 x 52 cm., and *Partie carrée*, 114 x 142 cm., the latter deliberately combining eighteenth-century and modern dress (Salon of 1870), appear as nos. 9 and 11, respectively, in the exhibition catalogue *James Jacques Joseph Tissot*, Museum of Art, Rhode Island School of Design, Providence, Rhode Island, 28 February-29 March 1968, and Art Gallery of Ontario, Toronto, 6 April-5 May 1968. Sarraute has cited an earlier painting, well known to Bazille, by Glaize, *Le Goûter champêtre de M. Bruyas* (Musée Fabre, Montpellier), as a possible source for Monet's painting, citing particularly the large tree at the right of the composition; *Bulletin du laboratoire du Musée du Louvre*, p. 48.

81. It is difficult to determine at what stages during Monet's sojourn at Chailly these landscapes were done. One of them [19] indicates an autumn coloration and could even date from after Bazille's departure in September. It may also represent early spring with autumn leaves from the previous year still on the ground. I tend to agree with Champa's proposed sequence, p. 274: *Route du Bas-Bréau* [19]; *La Route de Chailly à Fontainebleau* [8]; *Le Pavé de Chailly dans la forêt de Fontainebleau* [7].

82. *La Revue du Louvre*, pp. 91–92. The dress appears again worn by the seated woman in the foreground of the *Femmes au jardin* [45].

83. Surviving drawings by Monet are so few that it is all but impossible to establish a precise dating on a comparative basis. In fact, the authorship of the Davis and Paul Mellon drawings [30, 32] is not certain. Neither of them is signed, and the circumstances of their discovery by Sarraute at the Bazille estate in 1947 does not assure their authenticity. It is my opinion, however, that they are by Monet. The recent appearance of the ensemble sketch in the Marmottan sketchbook (see p. 24 and n. 18 above), however, confirms, through its style, that the Paul Mellon drawing is authentic, and it is my opinion that the Davis drawing, as well, is by Monet. Bazille either received them directly from Monet or retrieved them after the latter had discarded them during or shortly after work on the *Déjeuner sur l'herbe*.

84. The only male figures where Bazille's features are not recognizable are the seated ones fourth from left and fourth from right. The latter could be Sisley, who may have visited Monet and Bazille at Chailly in September. Daulte, p. 171, identifies Sisley as the reclining figure at the right of Bazille's *Repos sur l'herbe* [10].

85. X-ray examination of the Moscow painting conducted at the Pushkin Museum in 1963 has revealed that Monet initially made these figures taller, closer to the size of the larger figures in the Washington study. He reduced their height during the course of work on the canvas. See commentary to pl. 1 by E. Gyeorgiyevskaya in Sapego, *Claude Monet*.

86. A detail photograph of this area in color, albeit too warm and insufficiently varied in hue, may be found in Sapego, pl. 1.

87. The connection between artistic independence and a free, sketchy, or crude style was gradually developed during the middle and later years of the nineteenth century. Contemporary commentators upon Courbet's work noted or stressed the connection between his somewhat rude manner of painting and the 'democratic' character of his subject matter; see, e.g. the observations of de Geoffroy and Champfleury cited in Linda Nochlin, 'Innovation and Tradition in Courbet's *Burial at Ornans*', *Essays in Honor of Walter Friedlaender*, New York, 1965, esp. pp. 122–3. See also idem, 'Gustave Courbet's *Meeting*: A Portrait of the Artist as a Wandering Jew', *Art Bulletin*, XLIX, September 1967, pp. 209–22 *passim*. In his review of the Salon des Refusés in 1863 Théophile Thoré noted a tendency toward a new style in the somewhat odd and rough manner of execution of many of the rejected painters. He saw them

as working in opposition to the academic emphasis upon finish, and he described the conditions, so close to those of Monet as he worked on the Moscow sketch, in which the painter must see and render differently: 'Mettons que la peinture puisse faire voir les menus details d'une figure de grandeur naturelle, isolée sur un fond neutre; mais quand la figure est éloignée, mais quand les groupes se compliquent, mais dans les accessoires et les lointains, mais dans le paysage, mais sous la lumière avec ses dégradations jusqu'à l'ombre, le *fini* disparait, et l'artiste n' a plus qu'à rendre l'aspect général, l'image complexe dans ses accents significatifs.' 'Salon de 1863', *Salons de W. Bürger*, I, pp. 414-15. In this connection Albert Boime has cited a rift between the champions of the sketch and of finish as one result of the Salon des Refusés; *Art Quarterly*, pp. 414-15. Some critics came to see a link between breadth of execution and originality or truth. In 1866, Jean Rousseau praised Pissarro for achieving originality through 'l'énergie abrupte de l'exécution' ('Le Salon de 1866', *L'Univers illustré*, 9ᵉ année, 4 July 1866, p. 447), and, in 1868, Zola stressed the truth in rendering nature attained by Monet through the freedom and roughness of his application; *Salons*, pp. 130-31.

88. *Impressionist Paintings in the Louvre*, p. 15.

89. The left-hand fragment used to be exhibited in a small room on the ground floor of the Jeu de Paume, in the south-east corner of the building. For several years it was hung centered on the east wall and was visible through the doorway as one stepped well back into the adjoining room. Viewed thus, from a considerable distance, the spatial effect of the painting may be fully appreciated. The dark band of the trees behind the figures recedes strongly, and by contrast the light-colored leaves overhead seem to come well forward. The volumetric figures assume an Uccello-like wooden relief, and are convincingly established in space. The expression of depth in the scene is so forceful that it may well be termed stereoscopic; unlike the situation in stereoscopic photography, however, where each figure or object within the space is seen as planar, Monet's figures do not relinquish their volumetric identity.

90. For a discussion of this point, along with bibliographical references, see my entry for Manet's etching of this subject in the exhibition catalogue *Manet and Spain*, The University of Michigan Museum of Art, 19 January-2 March 1969, no. 16.

91. See Anne C. Hanson, 'A Group of Marine Paintings by Manet', *Art Bulletin*, XLIV, December 1962, pp. 332-6 *passim*.

92. Working on this canvas in the garden of a rented house near

Ville-d'Avray, Monet dug a trench into which the eight-foot-high painting could be lowered so as to facilitate work on the upper section without at the same time appreciably changing his viewing point.

93. See preceding note. Monet must have worked on the canvas throughout the summer, but when he left Ville-d'Avray it was still not completed. He took it with him to Normandy, where it continued to occupy his attention during the fall and possibly into the winter. (See the letter from Dubourg to Boudin, 2 February 1867, in which the painting is described and it is made quite clear that Monet worked on it in Normandy; Jean-Aubry, *Boudin*, p. 64. In its present condition the upper paint layer shows several areas of rather severe cracking, indicating repeated overpaintings.) Thus Monet failed once again to realize his ambition to execute a large painting entirely out of doors.

94. Although presented almost parenthetically here, this point should be stressed and will be, in a larger context, in the remainder of this essay. Questions of financial difficulties and of dissatisfaction with the results of having followed Courbet's advice (if, indeed, it was ever given) must take second place to the evidence of the painting itself as we see it today even in its mutilated condition. Monet was attempting to reconcile a traditional conception of the canvas as a window on the world with a new and innovative conception of the canvas as a palpable entity, the identity and nature of which was to be respected and emphasized. His inability to reconcile these aims is at the root of his failure to complete the painting. This view, central to my understanding of Monet's *Déjeuner*, has been offered also by Champa, p. 300.

95. One finds numerous instances, in the critical writings of the period, where the need to formulate a modern style of painting, appropriate to a new era and to a new contemporary subject matter, is stressed. In almost all such instances the authority of the antique is cited as something which continues to hold its anachronistic sway and which must be overcome if a new style is to emerge. Thus, e.g., Thoré in 1864: 'La beauté, l'idéal et le style ... ne sont point du tout les mêmes pour l'homme du dix-neuvième siècle que pour le païen ou le catholique. La critique française, en général, ne semble être ni de son temps ni de son pays, lorsqu'elle prône l'idéal et le style qui appartenaient jadis à la Grèce ou à l'Italie ... il y a autant de styles que d'époques, que d'écoles, et même que de grands artistes ... Je souhaiterais à la France contemporaine d'avoir des peintres qui la représentent aussi gentiment que Watteau représenta la Régence.' *Salons de W. Bürger*, II, pp. 20-21. Hector de

Callias: 'La poésie des temps modernes n'est pas toute faite, comme celle des temps anciens: il faut la deviner, la dégager et inventer des formes pour la rendre.' 'La Peinture et les peintres français. Hippolyte Bellangé', *Musée des familles*, XXXII, December 1864, p. 94. In 1867, Zola entitled his article on Manet 'Une Nouvelle manière en peinture: Edouard Manet' and stressed the novelties of the artist's style. In Manet's statement accompanying his 1867 exhibition he acknowledged the importance of the question of a new style of painting, if only – and characteristically – in the negative: 'M. Manet . . . n'a prétendu ni renverser une ancienne peinture, ni en créer une nouvelle. Il a cherché simplement à être lui-même et non autre.' Tabarant, *Manet et ses oeuvres*, p. 136. For a more extended but still only tentative discussion of this question, see my dissertation, pp. 1–17.

96. *La Femme au perroquet* was not the original title of the painting; it was earlier called *La Femme en rose* and *Jeune femme en 1866*, under which title it was shown at Manet's 1867 one-man exhibition. For the paintings exhibited at the rue Guyot in 1866, see Tabarant, *Manet et ses oeuvres*, p. 124.

97. Degas's concern for the two-dimensional coordination and adjustment of his painted compositions in 1866 and the immediately succeeding years is evidenced in such works as *Mlle Fiocre dans le Ballet de la Source*, c. 1866–8 (Brooklyn Museum; P. A. Lemoisne, *Degas et son oeuvre*, II, Paris: P. Brame et C. M. de Hauke, 1946, no. 146) and *L'Orchestre de l'Opéra*, c. 1868–9 (Louvre; Lemoisne, no. 186).

98. Monet made brief trips to Paris from Ville-d'Avray in May 1866. He had two canvases at the Salon, which opened 1 May, and, as a result of his success, sold 800 francs worth of paintings in the first two or three weeks following the Salon opening; see Appendix, letter II, p. 93.

99. Space is funneled back and to the right, the sense of recession abetted by the overlapping of forms and the proper diminution in size of the rear figure and of the leaves upon the trees and bushes. There is a considerable sense, too, as Seitz, *Claude Monet*, 1960, p. 70, has pointed out, that the figures form a large oval in depth, revolving about the hub of the central tree. The third dimension is clearly presented, but it is also firmly controlled by a marshalling of means which gives the dominant role to the two-dimensional surface of the canvas.

100. The latter two points, having to do with the introduction of a system of hue relationships in preference to traditional chiaroscuro and with the stress upon the play of color independent of drawn form, are

stressed by Pierre Francastel in his admirable analysis of the *Femmes au jardin*; see *Nouveau dessin, nouvelle peinture*, Paris: Librairie de Médicis, 1946, ch. 2, esp. pp. 40–42, 50–52, and *Peinture et société*, Lyon: Audin, 1951, ch. 2, esp. p. 155. Another major discussion of the style of the *Femmes* is provided by Lionello Venturi, 'L'Impressionnisme, rupture de la tradition', *Cahiers d'histoire mondiale*, III, 1956, pp. 341–2; reprinted in Eng. trans. in G. S. Métraux and F. Crouzet, eds., *The Nineteenth-Century World*, New York: Mentor, 1963, pp. 407–36, esp. p. 420. Venturi, rightly I believe, considers the *Femmes* as the first major work in which Monet realized a unified artistic vision, but in attempting to evaluate the painting in relation to mature Impressionism he overlooks the question of its positive contribution to the esthetic of the 1860s. See also Champa, pp. 305–16. Champa's view that the *Femmes* 'responds to a perceptual challenge without imposing an obvious conceptual scheme in the solution' (p. 316) tends to parallel Francastel's and runs counter to the view presented here and in my dissertation, ch. 6, where the belief that Monet exercised a predetermined, synthetic control over the painting from the first is offered.

101. The letter was written from Sèvres near Ville-d'Avray as stated in the text below. A date near the end of April is indicated, for Monet says that he needs money by 1 May, undoubtedly to pay his most pressing bills, perhaps including the rent on his new house. Also, there is no mention of the Salon, which opened on 1 May. Another factor in dating the letter would be the date of Gautier's marriage, to which Monet refers, but which I have been unable to ascertain.

102. Underlining in the original. The important works set aside must have included the *Déjeuner sur l'herbe* (see above, p. 30).

103. Monet's two paintings exhibited at the Salon were *Camille* and *Forêt de Fontainebleau*. Zola's review of *Camille*, which Gautier and others sent to Mme Lecadre, appeared in *L'Evénement* on 11 May 1866; see Zola, *Salons*, pp. 70–71.

104. This sentence and part of the preceding one have been quoted previously by Marthe de Fels, *La Vie de Claude Monet*, p. 96. She had access to the Monet-Gautier letters due to the generosity of Robert Rey; M. de Fels, p. 229. The two letters presented here were since separated from the group and bought by the Bibliothèque d'art et d'archéologie in 1958. The remainder of the letters is apparently lost today; see Mount, *Monet*, p. 400.

List of Illustrations

Color plates: *Le Déjeuner sur l'herbe*, detail of left-hand section. By Claude Monet, 1865–6. Paris, Musée du Jeu de Paume, Louvre. (Photo: Agraci.)

Sketch for *Le Déjeuner sur l'herbe*. By Claude Monet, 1865. Moscow, Pushkin Museum. (Photo: Museum.)

1. Photograph of Monet and the Duc de Trévise in Monet's studio at Giverny, 1920. (Photo: Roger-Viollet.)

2. *Le Déjeuner sur l'herbe*, central section. By Claude Monet, 1865–6. Oil on canvas, 248 x 217 cm. Studio stamp, bottom right: Claude Monet. Paris, Eknayan Collection. (Photo: Roger-Viollet.)

3. Sketch for *Le Déjeuner sur l'herbe*. By Claude Monet, 1865–6. Oil on canvas, 130 x 181 cm. Signed and dated bottom left center: Claude Monet 66. Moscow, Pushkin Museum. (Photo: Durand-Ruel.)

4. *Le Déjeuner sur l'herbe*, left-hand section. By Claude Monet, 1865–6. Oil on canvas, 418 x 150 cm. Paris, Musée du Jeu de Paume, Louvre. (Photo: Agraci.)

5. Diagram of surviving fragments of Monet's *Le Déjeuner sur l'herbe*. (Photo: Durand-Ruel.)

6. *La Pointe de la Hève à marée basse*. By Claude Monet, 1864. Present whereabouts unknown. (Photo: Durand-Ruel.)

7. *Le Pavé de Chailly dans la forêt de Fontainebleau*. By Claude Monet, 1865. Copenhagen, Ordrupgaard Collection. (Photo: Durand-Ruel.)

8. *La Route de Chailly à Fontainebleau*. By Claude Monet, 1865. Lausanne, private collection. (Photo: Giraudon.)

9. *L'Ambulance improvisée*. By Frédéric Bazille, 1865. Paris, Musée du Jeu de Paume, Louvre. (Photo: Musées Nationaux.)

10. *Repos sur l'herbe*. By Frédéric Bazille, 1865. Paris, private collection. (Photo: Marc Vaux; courtesy of François Daulte.)

11. *Bazille and Camille - study for 'Le Déjeuner sur l'herbe'*. By Claude Monet, 1865. Oil on canvas, 94 x 70 cm. Signed bottom right: Claude Monet. Washington D.C., National Gallery of Art, Ailsa Mellon Bruce Collection. (Photo: National Gallery of Art.)

12. *Camille*. By Claude Monet, 1866. Bremen, Kunsthalle. (Photo: Museum.)

13. *Proudhon and his Family.* By Gustave Courbet, 1865-7. Paris, Petit Palais. (Photo: Archives.)

14. *Le Déjeuner sur l'herbe.* By Edouard Manet, 1863. Paris, Musée du Jeu de Paume, Louvre. (Photo: Bulloz.)

15. *La Musique aux Tuileries.* By Edouard Manet, 1862. London, National Gallery. (Photo: National Gallery.)

16. *Promenade sur les remparts de Paris.* By Augustin de Saint-Aubin, 1760. (Photo: Bibliothèque Nationale.)

17. Engraving from *L'Illustration*, XXXV, 2 June 1860, p. 348. (Photo: Bibliothèque Nationale.)

18. Anonymous photograph, 1860s. Gernsheim Collection, Humanities Research Center, The University of Texas at Austin.

19. *Route du Bas-Bréau.* By Claude Monet, 1865. Paris, Musée du Jeu de Paume, Louvre. (Photo: Giraudon.)

20. Photograph of a road in Fontainbleau forest, taken by Gustave Le Gray, 1850s. (Photo: Bibliothèque Nationale.)

21. *Une halte de chasse.* By Carle van Loo, 1737. Paris, Musée du Louvre. (Photo: Agraci.)

22. *Les Champs-Elysées.* By Antoine Watteau, *c.* 1716-19. London, The Wallace Collection. (Photo: Crown Copyright.)

23. Detail of 4.

24. X-ray photograph of 23. By courtesy of the Laboratoire du Musée du Louvre.

25. Detail of 4.

26. Fashion plate from *Les Modes parisiennes*, 1863.

27. Fashion plate from *Le Bon Ton*, Paris, October 1863.

28. *Les Demoiselles des bords de la Seine.* By Gustave Courbet, 1856. Paris, Petit Palais. (Photo: Giraudon.)

29. *Le Déjeuner sur l'herbe.* By James Tissot, mid-1860s. London, private collection.

30. Sketch of Camille. By Claude Monet, *c.* 1865-6. Charcoal, 47 x 31 cm. New York, Richard S. Davis collection. (Photo: courtesy of Mr Davis.)

31. See 11.

32. Study for '*Le Déjeuner sur l'herbe*'. By Claude Monet, 1865. Charcoal on gray-blue paper, 31 x 47 cm. Washington, D.C., Mr and Mrs Paul Mellon collection. (Photo: courtesy of Richard S. Davis.)

33. See 3.

Bibliography of Main Sources

Adhémar, Hélène, 'Modifications apportées par Monet à son Déjeuner sur l'herbe de 1865 à 1866', *Bulletin du laboratoire du Musée de Louvre*, no. 3, June 1958, pp. 37–41.

Baudelaire, Charles, *Art in Paris 1845–1862*, trans. and ed. Jonathan Mayne, London: Phaidon, 1965.

—, *The Painter of Modern Life and other Essays*, trans. and ed. Jonathan Mayne, London: Phaidon, 1964.

Bazin, Germain, *Impressionist Paintings in the Louvre*, trans. S. Cunliffe-Owen, 2nd ed. London, 1959.

Boime, Albert, 'The Salon des Refusés and the Evolution of Modern Art', *The Art Quarterly*, XXXII, Winter 1969, pp. 411–26.

Cahen, Gustave, *Eugène Boudin, sa vie et son oeuvre*, Paris: Floury, 1900

Castagnary, Jules Antoine. *Salons, 1857–1870*, 2 vols. Paris: Charpentier, 1892.

Champa, Kermit, 'The Genesis of Impressionism', Unpublished Ph.D. dissertation, Harvard University, 1964.

Daulte, François, *Frédéric Bazille et son temps*, Geneva: Cailler, 1952.

Elder, Marc, *Chez Claude Monet à Giverny*, Paris: Bernheim-jeune, 1924.

Fels, Marthe de, *La Vie de Claude Monet*, Paris: Gallimard, 1929.

Fried, Michael, 'Manet's Sources, Aspects of his Art, 1859–1865', *Artforum*, VII, March 1969.

Geffroy, Gustave, *Claude Monet, sa vie, son oeuvre*, 2 vols. Paris: Crès, 1924 (1 vol. ed., 1922).

Jean-Aubry, Georges, *Eugène Boudin*, Paris: Bernheim-jeune, 1922.

Mack, Gerstle, *Gustave Courbet*, New York, 1951.

Mount, Charles M., *Monet*, New York, 1966.

Poulain, Gaston, *Bazille et ses amis*, Paris: La Renaissance du livre, 1932.

Rewald, John, *The History of Impressionism*, rev. and enl. ed. New York, 1961.

Roskill, Mark, 'Early Impressionism and the Fashion Print', *Burlington Magazine*, CXII, June 1970, pp. 391–5.

Sapego, I., *Claude Monet*, French trans. V. Friedman and I. Oshurkova. Leningrad: Aurora, 1969.

Sarraute, Gabriel, 'Contribution à l'étude du Déjeuner sur l'herbe de Monet', *Bulletin du laboratoire du Musée du Louvre*, no. 3, June 1958, pp. 46–51.

—, 'Deux dessins inédits de Claude Monet', *La Revue du Louvre*, XII, 1962, pp. 91–2.

Seitz, William, *Claude Monet*, New York: Abrams, 1960.

Tabarant, Adolphe, *Manet et ses oeuvres*, Paris: Gallimard, 1947.

Thiébault-Sisson, 'Claude Monet: Les années d'épreuves', *Le Temps*, 26 November 1900 (English trans: 'Claude Monet: The Artist as a Young Man', *Art News Annual*, XXVI, 1957, pp. 127–8, 196–9).

Thoré, Théophile, *Salons de W. Bürger, 1861 à 1868*. 2 vols. Paris: Renouard, 1870.

Trévise, Duc de, 'Le Pèlerinage à Giverny', *La Revue de l'art ancien et moderne*, LI, January 1927, pp. 42–50; February 1927, pp. 121–34.

Zola, Emile, *Salons*, ed. F. W. J. Hemmings and Robert J. Niess, Paris: Minard; Geneva: E. Droz, 1959.

Index